DEC -- 2017

HRAC

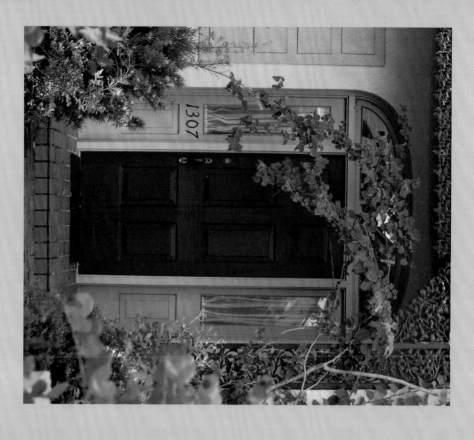

River & Road

UNIVERSITY PRESS OF FLORIDA

Florida A&M University, Tallahassee
Florida Atlantic University, Boca Raton
Florida Gulf Coast University, Ft. Myers
Florida International University, Miami
Florida State University, Tallahassee
New College of Florida, Sarasota
University of Central Florida, Orlando
University of Florida, Gainesville
University of North Florida, Jacksonville
University of South Florida, Tampa
University of West Florida, Pensacola

River & Road

Fort Myers Architecture from Craftsman to Modern

Jared Beck and Pamela Miner

University Press of Florida

Gainesville
Tallahassee
Tampa
Boca Raton
Pensacola
Orlando
Miami
Jacksonville
Ft. Myers
Sarasota

This book may be available in an electronic edition.

22 21 20 19 18 17 6 5 4 3 2 1

Library of Congress Control Number: 2016958012
ISBN 978-0-8130-5438-4

The University Press of Florida is the scholarly publishing agency for the
State University System of Florida, comprising Florida A&M University,
Florida Atlantic University, Florida Gulf Coast University, Florida
International University, Florida State University, New College of Florida,
University of Central Florida, University of Florida, University of North
Florida, University of South Florida, and University of West Florida.

University Press of Florida
15 Northwest 15th Street
Gainesville, FL 32611-2079
http://upress.ufl.edu

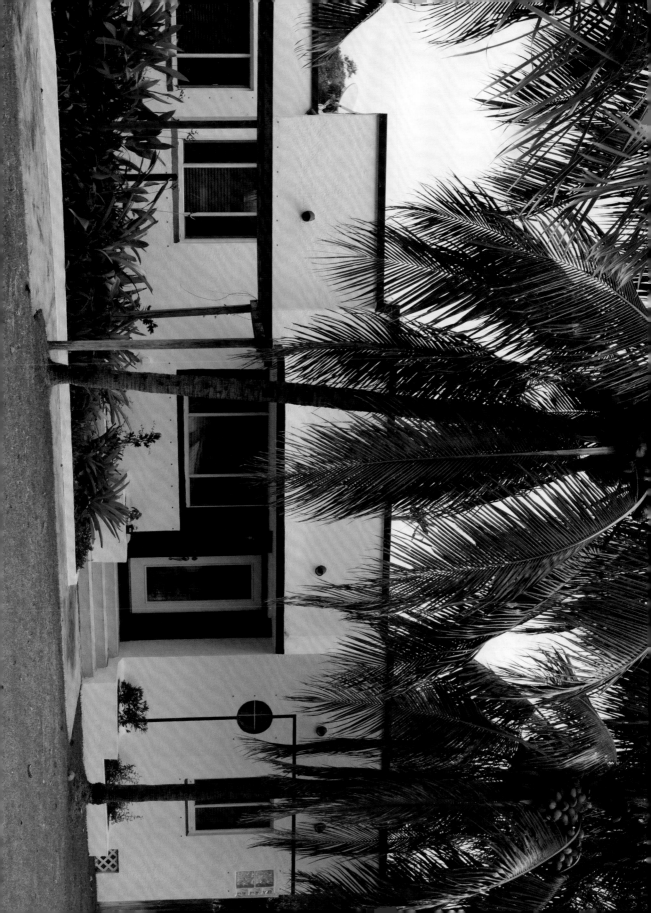

Contents

Introduction 1

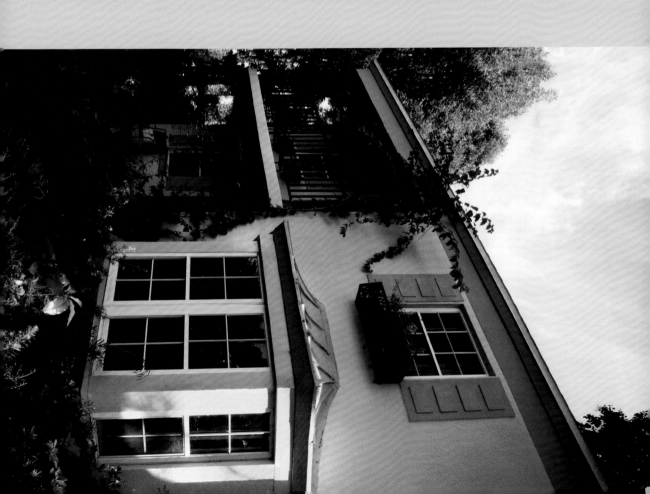

River & Road

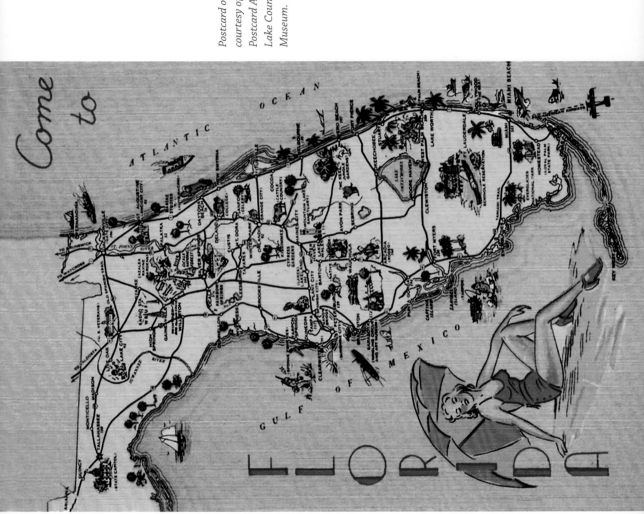

Introduction

IMAGINING LIFE IN FLORIDA creates a vision of lounging on a sun-drenched beach, with sand between the toes and a fruity drink in hand. Though such scenes exist in the tropical state, a good deal more resides within its water-lined perimeter. A tour of the small Gulf Coast city of Fort Myers is chock-full of encounters with diverse, dynamic places and people.

Fort Myers grew from a rural town into the preeminent urban center of Southwest Florida during the twentieth century. Its evolution illustrates the American story. Assembled along a river and a road is an eclectic blend of houses that together create historically and culturally vibrant neighborhoods representing lifeways of the city's past and present.

The mile-wide Caloosahatchee River flows south from Lake Okeechobee, Florida's largest inland body of water, and opens into the Gulf of Mexico. The moniker comes from the region's indigenous Calusa Indian tribe. An essential natural resource for millennia, the river continues to be a vital extension of Fort Myers.

McGregor Boulevard is a more recent integral artery for Fort Myers. Its namesake is Ambrose McGregor, winter resident and business partner of Standard Oil tycoon John D. Rockefeller. The fifteen-mile road ends as the gateway to Sanibel and Captiva Islands. However, its heart is the several-mile stretch from the western edge of historic downtown to the city's southernmost limit.

An early view of the Caloosahatchee River. Photograph courtesy of the Southwest Florida Historical Society.

The river and road area, circa 1925. Photograph courtesy of Brent Crawford.

The blending of Mother Nature and human ingenuity began early in the area. The Calusa civilization ruled the region for nearly one thousand years. Natives carved through the sandy soil to improve access to the Caloosahatchee—a life source of water, fish, and trade. Shell mounds formed from the natives' trash rise today as man-made hills dotting the landscape.

Disease and conflict brought by Spanish conquistadors ended Calusa dominance by the mid-1700s. With Europeans only spattered throughout Juan Ponce de León's aptly named La Florida (the flower) peninsula, displaced southeastern American tribes moved to claim the region for themselves. Runaway slaves joined the Seminole and Creek Indians. When Florida was welcomed to U.S. statehood in 1845, the presence of the federal government increased, and settlers arrived by the oxcart load.

Nestled in the hook of the Caloosahatchee River, a pine tree hammock was transformed into a U.S. military installation during the Seminole War in the 1850s. Major David E. Twiggs selected the name Fort Myers in honor of his son-in-law, Colonel Abraham C. Myers, then chief quartermaster for the Department of Florida. Ironically, neither ever visited the fort.

The fort was abandoned by 1858, when the Seminole

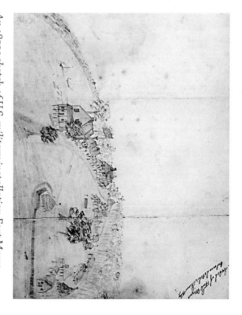

An 1850s sketch of U.S. military installation Fort Myers.
Image courtesy of the Southwest Florida Museum of History.

Wars ended, yet the activity had drawn more people to the area. Some pioneers wrangled roaming Spanish scrub cattle into herds, and markets for meat, hides, and tallow were generated from Georgia to Cuba. Soon a mix of characters inhabited the region.

Fort Myers was recommissioned in 1864 as a Union stronghold in Confederate Florida. An integral task of the soldiers was to obtain beef to feed the large federal army. The southernmost skirmish of the "War Between the States" occurred on February 21, 1865, when the local

became the core lined with homes and businesses—general stores, clothiers, blacksmiths, doctors, druggists, and a newspaper office.

The expansion of a communication system was important for area growth. In an effort to extend the United States' influence in the Western Hemisphere by setting up trade programs in the West Indies and Central America, the federal government partnered with the International Ocean Telegraph Company to develop a telegraph system from Punta Rassa to Key West, then on to Cuba. Word came through Punta Rassa of the battleship *Maine* explosion in Cuba, the impetus for the United States to enter the Spanish-American War in 1898.

Today, Punta Rassa is a signpost at the turn into Sanibel Harbor Resort. In the late 1800s, cattle king Jacob Summerlin developed the hamlet into a significant American port positioned on the Gulf of Mexico. A rough trail formed to keep both communication and cattle flowing from Orlando through Fort Myers to Punta Rassa.

The aging Summerlin returned to Orlando, leaving his coastal legacy to his son Samuel. The younger Summerlin stayed in the area for another decade before returning to his family in Central Florida. Famed inventor Thomas

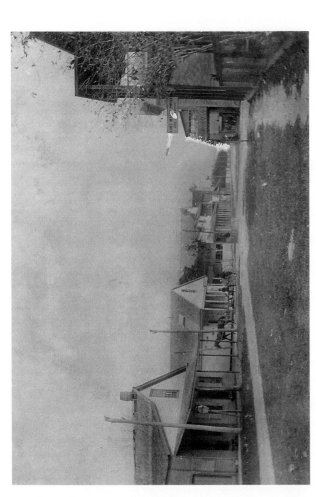

The village of Fort Myers at the turn of the twentieth century. Photograph courtesy of the Southwest Florida Historical Society.

militia, the Cattle Guard Battalion, attacked the fort in retaliation for the latest practice by the Union Army of "stealing" cows. The daylong incident closed with a northern victory.

Discarded for good at the end of the war in 1865, settlers razed the fort and salvaged the frame buildings to establish the beginnings of a rural early Florida town. The civilian Fort Myers appeared from a dirt grid. Front Street

George Shultz's hotel was the hub for business and socializing in Punta Rassa. Photograph courtesy of the Southwest Florida Historical Society.

Edison purchased a riverfront property from Samuel in 1885 as a new era began in Fort Myers.

Edison shared his winter retreat with many family members, friends, and associates. He also is said to have revealed the town to the world by announcing, "There is only one Fort Myers, and ninety million people are going to find it out." Automobile magnate Henry Ford became a regular visitor after purchasing the home adjacent to Edison's beloved Seminole Lodge. Though work was on

the agenda, the two spent many hours boating, fishing, and telling jokes in paradise.

Like Edison, others were drawn by the budding national recognition of the region's recreational sports fishing and tropical climate. After New York outdoorsman William H. Wood pulled a tarpon from the Caloosahatchee with a rod and reel in 1885, Fort Myers became known for the best "silver king" fishing in U.S. waters. More famous men, including artist Frederic Remington, President Theodore Roosevelt, and author Zane Grey, ventured out into Gulf waters to hook the "big one."

As visitors and seasonal folks filtered through, Fort Myers began to swell with permanent residents as the twentieth century dawned. Sugar, citrus and fruits, fish, and flower businesses provided jobs for both pioneer descendants and northern transplants. The arrival of the railroad in 1904 generated a new phase for the movement of goods and people.

Many of the framed dwellings constructed from the fort had burned down or were aging by 1900. Surnames such as Hendry, Gonzalez, Heitman, Langford, and Tonnelier joined in the building boom of the early 1900s. These brick and granite endeavors are the fabric of downtown Fort Myers today.

Downtown Fort Myers today. Photograph courtesy of Andrew West.

The scene that materialized during this era created a lasting nickname for Fort Myers. New Yorker Hugh O'Neill came to town for a business trip in 1892, adding to his agenda a tarpon fishing trip to Punta Rassa. He enjoyed the excursion and wanted others to have the experience. O'Neill built the Fort Myers Hotel in 1898, and after flanking the street fronting the hotel with royal palms, it was renamed the Royal Palm Hotel. Thomas Edison, who initially envisioned using royal poinciana as shade trees lining the street in front of his estate, later followed O'Neill's lead and selected royal palms. In 1907, city leaders accepted Edison's offer to provide funding for palms to be planted for several miles down Riverside Avenue—from Monroe Street, past his Seminole Lodge, to the Manuel's Branch creek—if the city financed their maintenance. The "City of Palms" readied for its evolution.

This period was significant to the expansion of the bustling town. As the availability and affordability of cars increased, so did the need for decent roadways. Folks were eager to venture down the road wherever it could take them. State and local leaders wanted to ensure that Southwest Florida was along for the ride. Funds were generated for the Dixie Highway and the Tamiami Trail, and

for bridges across numerous waterways. In rolled more permanent and seasonal residents, as well as the "tin can tourist."

The aforementioned Riverside Avenue, an homage to the Caloosahatchee River it followed, replaced the old telegraph and cattle trail as the connection between town and country strengthened. When use increased in the 1910s, Fort Myers city leaders decided to create

McGregor Boulevard takes a modern turn. Photograph courtesy of the Southwest Florida Historical Society.

"modern" roads that were shelled, curbed, and capable of draining copious amounts of rainfall. The decision to improve this transportation way was important. The newly christened McGregor Boulevard, financed by Tootie McGregor Terry, proved to be integral to the flourishing town.

Florida experienced a wild land boom in the 1920s; rampant speculation was the trend of the day. Investors intended to buy and sell at a hefty profit. The ability to vacation was no longer a luxury. World War I created prosperity for more Americans than ever before. They yearned to spend the money burning holes in their pockets. One of the first purchases for many was a Ford Model T automobile. Thousands of people desired to see the Sunshine State for themselves—then dreamed of building their own castle in the sand.

Northern investors were happy to oblige the folks pouring into Fort Myers during the Roaring Twenties. Though these developers called New York, Rhode Island, Iowa, Illinois, and Michigan home, their bank accounts dwelled and swelled in a distant coastal town. The novelty of the day, subdivision neighborhoods, sprouted up around the town center. A traditionally rural area transformed into a metropolitan appendage. By the end

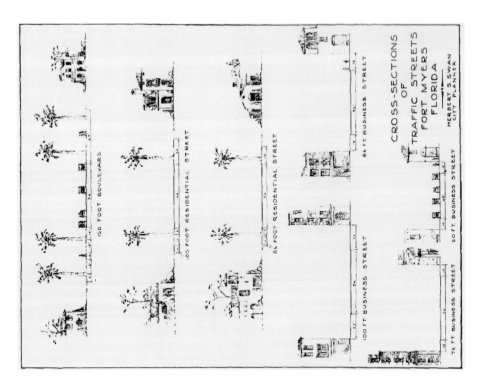

The Swan plan of 1926 presented a formal development plan for the city of Fort Myers. Plan courtesy of the City of Fort Myers.

of the 1920s, much of the latticed land was annexed into the city proper.

The roadway systems were modeled loosely along traditional urban block design while incorporating broad sweeping curves to create vistas framing significant homes and the existing landscape. A sense of grace, beauty, and function of traditional design was established and has remained virtually unchanged. As development continued in Fort Myers, this modified urban design has carried on throughout much of the corridor.

During the early development period in America, it was common for individual projects to be approved without consideration for surrounding land uses, access, or other subdivisions. Negative results surfaced by the 1920s. A movement for standardized land use zoning swept across the country and the era of comprehensive plans began; many such plans are used today to guide a community's growth.

Fort Myers joined the movement in 1926 when city leaders commissioned Herbert Swan, a well-respected New York City planner, to devise "The Fort Myers Plan" to guide the city's future. Challenged to include the downtown commercial center, the numerous built or approved subdivisions, and the varying road networks

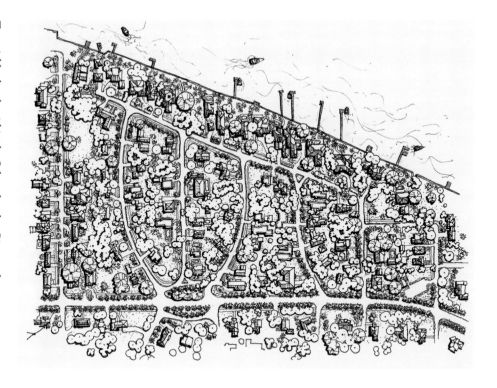

The neighborhoods within the Caloosahatchee River and McGregor Boulevard area. Sketch courtesy of Jared Beck.

already in place, Swan developed a plan that is still highly visible.

One of a handful of noticeable differences between the plan and the existing city is the absence of the Caloosahatchee riverfront roadway extending from downtown to the city limit at Colonial Boulevard. At a time when great value was placed on public access and the use of amenities such as waterways, the Swan plan called for both a waterfront promenade and a linear park as part of a fully connected street network along the western boundary of the McGregor Boulevard corridor. Developers were apparently unwilling to modify plans to incorporate this element. Thus, privatization of the waterfront occurred.

Dismissing parts of the plan also resulted in small undeveloped tracts, or "leftovers." Fortunately, the McGregor area has remained a desirable location to live. Over time, every section along the corridor has been built out.

Hundreds of homes appeared along the river and boulevard during the 1920s. The boom period houses were patterned after the trendy Iberian Peninsula style: Moorish, Spanish, Mission, or Mediterranean Revival. Florida's conquistador history perfectly suited the craze.

Spanish design elements such as tile, large windows, and balconies were well matched to the sultry climate.

Soon hard times fell on Southwest Florida. The hurricane of 1926 was a major storm that crossed the state. The disaster destroyed homes and businesses, killed thousands, and bankrupted communities. Following the hurricane, Fort Myers suffered deeply in the throes of the Great Florida Land Bust. Development was put on hold as investors lost money, banks closed, tax dollars shrank, and folks left in droves. The Great Depression of the 1930s affected Florida as it did the rest of America.

President Franklin Roosevelt's New Deal fingerprint brought some relief to Fort Myers. A substantial federal post office was erected (now the dynamic Sidney and Berne Davis Arts Center). And the welcoming waterfront park and Yacht Basin sculpted along the river's edge remain popular venues as well.

The few homes built, significantly renovated, or expanded in Fort Myers during this time were typically owned by those with substantial wealth who rode out the challenging times with minimal financial damage. Significantly, new construction occurred on the opposite end of the spectrum as well.

The government built two U.S. Army Air Corps bases in

the area in support of the World War II effort. Buckingham Field provided gunnery training, and Page Field delivered bombing training. Over twenty thousand soldiers and their families lived at these bases during this period.

Simple, modest tract homes dotted the peripheries of the bases to house enlisted men, their families, and others associated with the endeavor. Some veterans remained, and others returned as tourists or later as permanent residents after the war. Immigrants and retirees also increased the population of Fort Myers. The new crop of potential homeowners, financial incentives, and benefits for developers brought another building boom to Fort Myers in the postwar era.

World War II altered nearly every aspect of American life. The demands of the war led the country into a period of modernization and streamlining, from the manufacturing of heavy equipment to the design of common household appliances. Technologies and advancements in production, especially the incorporation of the assembly line system that created contemporary suburban tracts, shaped development and home-building.

Vacant lots from the bust era were developed in Fort Myers as growth resumed in the 1940s. In many neighborhoods the originally platted larger estates were subdivided, providing buyers with affordable parcels. This brought growth to the city and expansion southward along McGregor Boulevard. Progress is apparent in the wide range of home styles and sizes existing along this vital corridor.

Although the high-end estate vision first imagined by bold developers was diminished with much of this expansion, it did not lessen the quality of home construction. What appear to be relatively modest homes were sturdily built at a cost that today would likely be unattainable for similar-sized homes.

Much of the formality and ornamentation previously seen in architectural design, largely a result of the war deprivation and the premodern movement, began to be minimized or eliminated from home styles altogether. Though creative architects began to incorporate modern forms, lines, and features by the 1920s, these concepts were initially unknown in Fort Myers. The post–World War II era created the ideal context for innovation and experimentation. Looking forward, taking risks to obtain one's own slice of the prosperity pie, and putting it on display became the American creed.

Trendy modern architecture matched contemporary needs. Houses of the 1950s were built quickly and inexpensively with widespread appeal. The ranch-style house especially suited the lifestyle emerging on the Gulf Coast. Developers supplied the simple rectangle, with little to no decoration, as homes for the masses. The Sarasota School of Architecture, based some eighty miles north of Fort Myers, employed the recent midcentury Modernism and customized these homes for Florida living.

By the 1950s, the Sarasota School of Architecture solidified their position on the scene by articulating a distinctive approach to modern style. Significant to the Sarasota School is the use of site characteristics to influence and create the home's design, including playing with natural light, airiness of space, and the blurred lines between the indoors and outdoors easily captured in a tropical environment.

The popularity of the Modernist style began to wane as the twentieth century closed on Fort Myers. The ideal nuclear family disappeared with the end of the Cold War era in the early 1990s. A period of increased individual choice brought an eclectic mix of architectural styles. The concept that design became more personalized rather than following trends or settings is extensively demonstrated in Southwest Florida.

With quality construction, charmingly eclectic neighborhoods, ease of location to downtown, and the allure that has always existed around McGregor Boulevard and the Caloosahatchee River, these homes remain as desirable, if not more so, than when first built. These attractive qualities have enticed homeowners to invest in properties. Many homes in this area have undergone significant expansion and renovation to accommodate the changing needs and expectations of the modern day. As a result, the dream homes created flourish throughout the corridor.

Today, the Fort Myers area is proudly recognized as one of the top tourist destinations in the world. The city buzzes with assorted activity near the treasured sandy shores. Its present is a sum of its past, natural and man-made. Those who call Fort Myers home are honored to share the story through their architectural legacies. Enjoy this journey along a river and a road.

Iconic McGregor Boulevard today. Photograph courtesy of Andrew West.

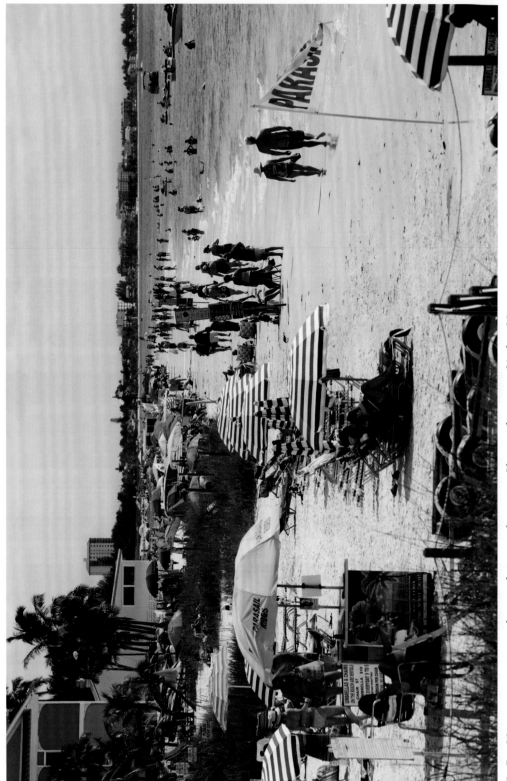

The Fort Myers region continues to be a popular tourist destination. Photograph courtesy of Andrew West.

1

Boom and Bust

Exaggerated details accentuate the Asian influence used in this Craftsman bungalow. Photograph courtesy of Andrew West.

1

Oriental Flair

1249 Osceola Drive

ORIGINALLY CALLING Northern California home, Mitch and Susan Hodge were quickly attracted to this whimsical Oriental Revival Craftsman bungalow when relocating to Fort Myers. They realized not too long after moving into the house how many others also shared an appreciation for the home simply by seeing the number of passersby photographing the unique treasure.

Though bungalow architecture arrived on the eastern shores of America as the trend for late-nineteenth century vacation homes, its place of notable prominence and permanence was in early twentieth-century California. The blurred lines between indoor and outdoor space was well suited to the state's year-round warm weather, and the low-profile style blended into the hilly landscape. Utilizing both spaces also provided more living area in a relatively small footprint. Thus, a comfortable home could be built at an affordable cost for the working family. Southwest Florida, which shared some similarities to California's climatic conditions, also saw a short period of rise in interest with the Craftsman bungalow, which is well demonstrated in the city's historic Dean Park neighborhood.

This Riverside Subdivision bungalow has proven to be well suited for the Florida

lifestyle the Hodges anticipated. The basic house form is characterized by the low-pitched, multigabled facade sitting elegantly behind the front porch. An exaggerated wide front door, centered between two tapered supporting columns, anchors the entry. The brick massing of the first floor emphasizes the horizontal nature of the style.

Repetitive gables on the main section blend with the porch. The flanking three-part windows consisting of a larger fixed panel and smaller, operable units, as well as the exposed wooden elements, reinforce the Craftsman influence. Far Eastern influence is principally revealed in the upswept rafter-end detail. The design is also used in the gabled peaks, decorative brackets, and fascia boards. The tapered open-frame porch columns also repeat this pattern.

The side-gabled main section and rise of the narrower stuccoed second story identifies the home even more specifically as an airplane bungalow. The fascination with modern air travel inspired the name. The "cockpit" situated above the "wings" formed by the lower roofline provided a place for panoramic viewing of the neighborhood.

Although examples of the Craftsman and Oriental mix exist throughout the country, it is uncertain why the original owner, Thomas Burdette, chose this blend. The selection is particularly odd at a time when Spanish or Mediterranean Revival influenced homes were highly desired. Especially since by the 1920s the Craftsman trend was losing popularity in Fort Myers.

One can assume Burdette wanted a home suited to the Florida climate, a hallmark of the Craftsman bungalow. Perhaps he wanted to add a bit of whimsy with the Oriental touches in a developing neighborhood of more traditional Georgian and Colonial Revival–styled homes. Nonetheless, he was visibly making a distinctive statement.

The floor plan defines an appropriate residence for the neighborhood. The main house is roughly 3,200 square feet, with three bedrooms and four bathrooms, living room, dining room, and kitchen. This size alone supports the stately vision that was desired for the Riverside Subdivision, and would appeal to an affluent growing family. A typical rear detached two-car garage with apartment above adds two additional bedrooms and a bathroom for family or guests. In later years, this feature was connected to the main home for more efficient use of both spaces.

Today, the presence of the intact original windows—

particularly the oversize ground floor windows mirrored by an additional expanse of windows on the second floor—offer a heightened level of detail and interest in the exterior design. This conjures images of bright rays of sunlight shining through, reflecting off dark hardwood floors. It is easy to imagine a family relaxing with windows open on a breezy spring afternoon. Whatever the reasons for the original owner's stylistic choice, this home's design continues to provide a wonderful sense of character on Osceola Drive.

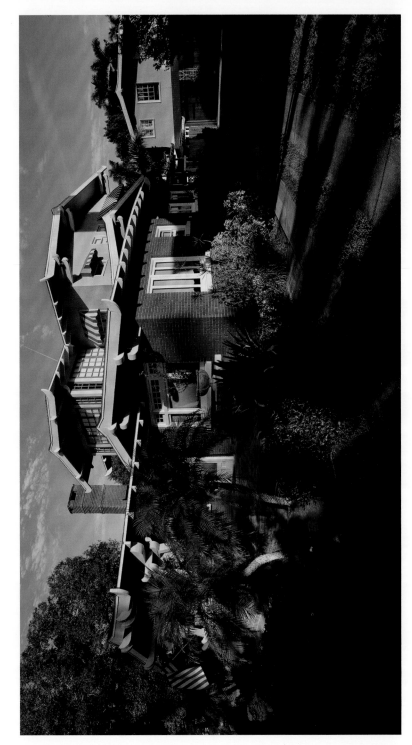

A rear garage and apartment situated behind the primary home duplicates the Oriental design. Photograph courtesy of Andrew West.

2

Villa Palmera

2642 McGregor Boulevard

CLASSIFIED AS A MEDITERRANEAN REVIVAL home, this Spanish-Italian-Moorish hybrid has a traditional central hall floor plan with flanking rooms. Exterior finish materials create a unique appearance not expected of the basic rectangular house form. This was one of many desirable premade (or kit) homes produced by nationally known Gordon Van Tine, a popular catalogue home manufacturer throughout the early twentieth century based in Davenport, Iowa. This selection was commonly referred to as the 535, 560, or Roberts model. Gordon Van Tine homes still exist throughout America today.

Included in the Graham-Shriver Subdivision, this property was envisioned from the beginning as a grand riverfront estate. The original lot, one hundred feet in width, extended lengthwise some six hundred feet from McGregor Boulevard to the Caloosahatchee River. With these attributes, and within a few minutes' walking distance of Thomas Edison's winter estate, Seminole Lodge, and Henry Ford's neighboring winter estate, The Mangoes, this property joined the ranks of the other grand homes being constructed at the time and furthered the recognition of McGregor Boulevard as the most prominent development corridor in the city.

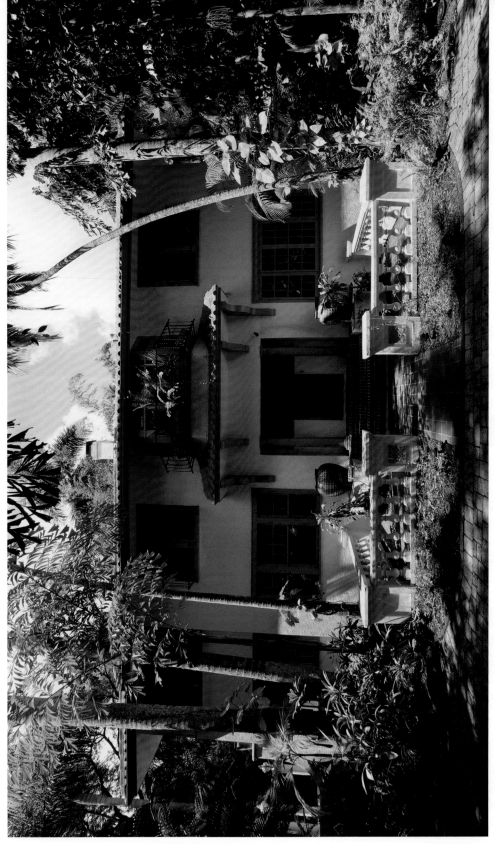

The 535, or Roberts model, was easily modified to fit the homeowner's taste. Photograph courtesy of Andrew West.

The basic shape of this kit home allowed regional and local influences to vary the exterior finishes, creating a variety of appearances. Regarded as grand for the time, the model included options for a first-floor sunporch, a second-floor sleeping porch, or both. These additions could be placed on one or both sides of the building. The overall size, stately design, and ability for expansion made this an appealing home for the successful family. In 1923 it could be purchased, including all materials and fixtures, for $2,862.

Assembled circa 1924, this Roberts model features a hipped-barrel tile roof and paired symmetrical six-over-one and eight-over-one double-hung windows, which even now contain the original wavy glass. The elaborate front entry, identical to the catalogue advertisement, is topped by a bow window with five casement openings. The original owner, Charles Shriver, lived in the guesthouse and supervised during the construction phase. The Shrivers chose a side bay sunporch, with French doors leading to a terrace, as well as a second-floor sleeping porch. The home also includes a basement, extremely rare in South Florida, particularly within such close proximity to the Caloosahatchee River.

The house design smartly took full advantage of the

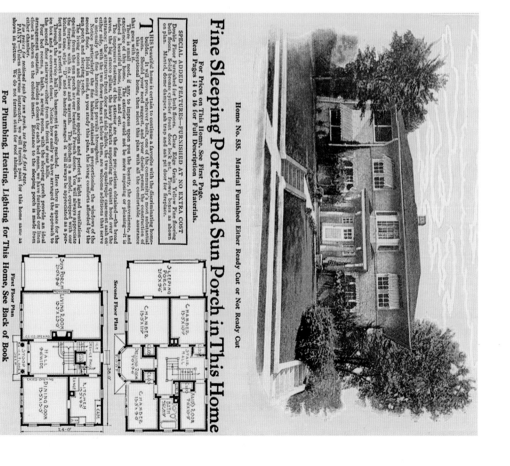

Advertisement for a Gordon Van Tine kit home. Original Gordon Van Tine sales brochure.

environment. Deep eaves provide partial protection from the sun while allowing in natural light. The window placement accommodates the cross-circulation of air, and the orientation toward the gardens, instead of the road, utilizes the expansive outdoors as additional living space.

Modifications and additions over the decades include a single-story family room and office, a multidenominational chapel with three 1902 stained glass windows, and a courtyard area that includes a pool with a waterfall, made of Florida limestone. Decorative elements placed throughout the interior reflect the whimsy and carpentry skills of various owners.

Equally impressive are the elaborate grounds. A tropical, almost jungle-like setting has evolved over the decades since the lot was cleared in the 1920s. Although the riverfront portion was sold off from the home parcel in 1944, it has maintained a commanding presence. Today, barely visible from the adjacent, heavily travelled McGregor Boulevard, the home sits nestled within a haven of mature trees, palms laden with epiphytes, festive bromeliads, tropical foliage, and bamboo. The yard provides a refuge for birds, mammals, and reptiles—especially since it is typically ten degrees cooler under the canopy,

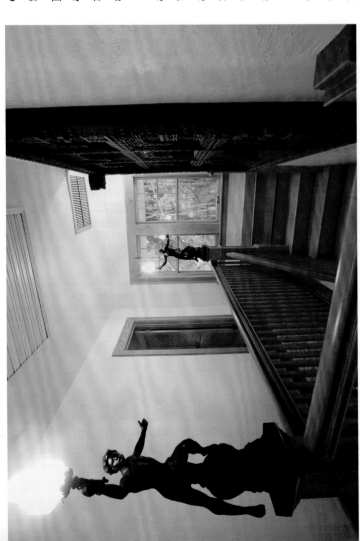

Elaborate fixtures adorn the central staircase on the second floor landing. Photograph courtesy of Andrew West.

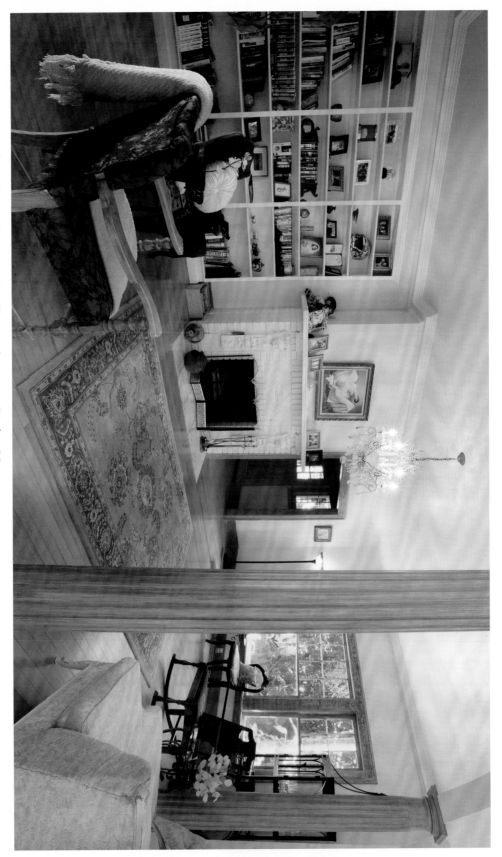

The gracious living room provides ample space for entertaining. Photograph courtesy of Andrew West.

according to longtime owner Marnie Paulus. Meandering walkways pass statues, massive carved wooden gates, water features, sitting areas, and terraces made even more romantic when illuminated by strings of tiny lights. Despite its origins as a mail order catalogue home, this property creates a secluded magical retreat.

Unlike many early estates in the city's history that remained with the original families for generations, this property has been bought and sold many times over the decades. With transactions occurring on average every four years for the first forty years of its existence, the ownership history adds to both the property's uniqueness and its intrigue.

The sales history includes a sense of loss and mystery, including a sale by the Shrivers at the height of the Florida land boom in 1925. Presumably a result of the real estate crash shortly thereafter, the home was sold back to the Shrivers in 1928. Sales records indicate that Eva Shriver, now widowed, assumed all debt on the property and continued to own it until selling it for a second time in 1936 to her neighbor, William McGuire. The year 1938 subsequently brought more curiosity as the property was again sold on February 21 to Carrie Seay, McGuire's niece, who promptly resold the home to her uncle one day later.

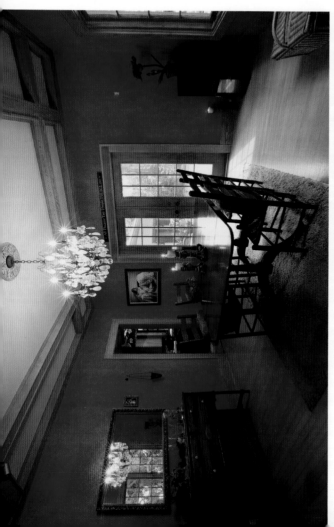

ABOVE: Wood elements such as the beams and wide baseboards reflect the Spanish influence. Photograph courtesy of Andrew West.

RIGHT: A bright space for an afternoon read. Photograph courtesy of Andrew West.

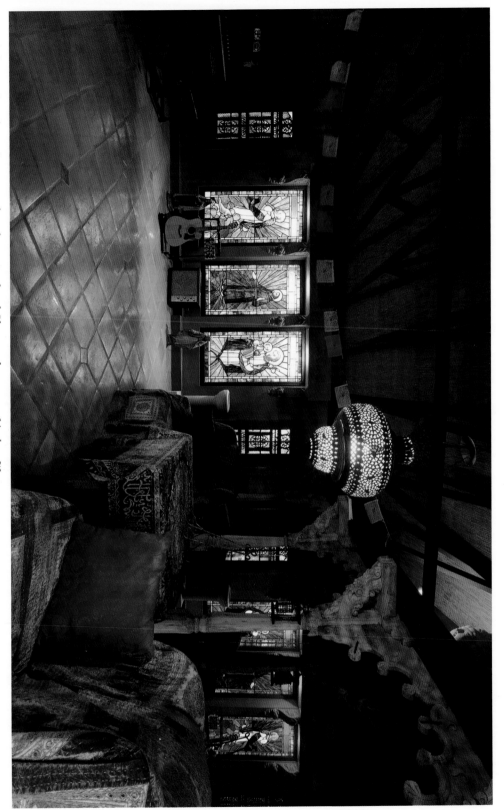

Stained glass windows dating from 1902 adorn the on-site chapel. Photograph courtesy of Andrew West.

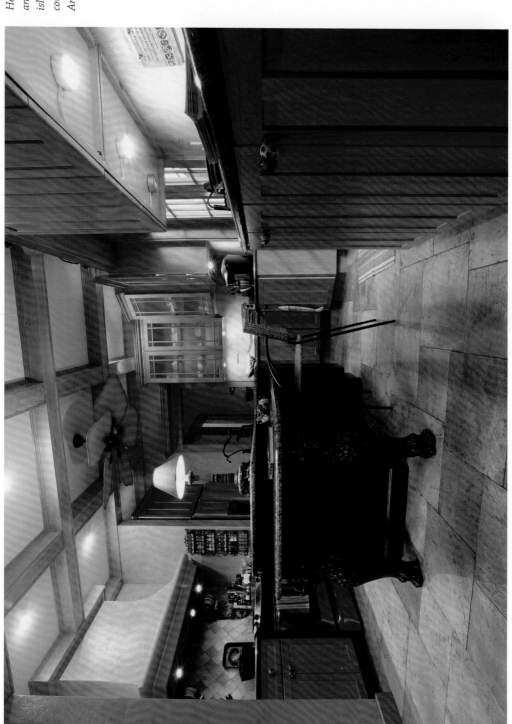

Heavily carved legs anchor the kitchen island. Photograph courtesy of Andrew West.

We can only speculate why this transaction occurred; perhaps it reflected a change of heart or creative financing. Harold and Mildred Crant owned the home from 1950 until 1965. A significant tie to regional history lies with the Crants and their four children. Locals and longtime visitors alike know their iconic Shell Factory. Originally built in Bonita Springs, the building, designed in the shape of an orange, was the must-stop destination to purchase

The Asian-influenced door leads to the tropical oasis. Photograph courtesy of Andrew West.

souvenirs and gifts representative of Southwest Florida and the Everglades.

During the time the Crant family lived in the home, the iconic dome-shaped building was destroyed by fire. The tourist attraction was subsequently rebuilt in North Fort Myers on the main route, Tamiami Trail (US 41), four miles north of Villa Palmera. The orange shape was abandoned in the second incarnation. With its now iconic and historic signage, the landmark continues to flourish as a local destination.

Whether used as a winter retreat during the early grandeur of South Florida in the early twentieth century or as a full-time residence, this tropical paradise has continually been occupied and cared for throughout the decades. A true treasure in Fort Myers, this kit home is exemplary among contemporaneous properties in Palm Beach, Miami, Sarasota, and other communities developed during the "boom years."

LEFT: *The Shell Factory continues to be a popular destination for locals and tourist alike. Postcard courtesy of Jared Beck.*

OPPOSITE: *Illumination of the side patio creates a spectacular evening spot. Photograph courtesy of Andrew West.*

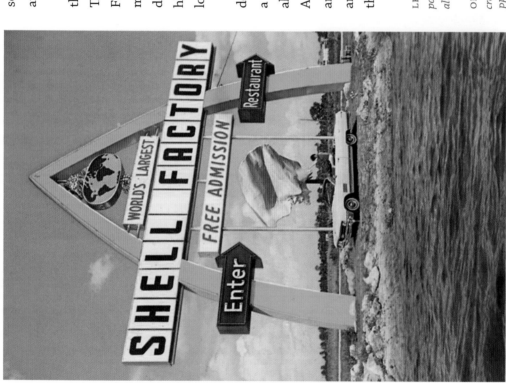

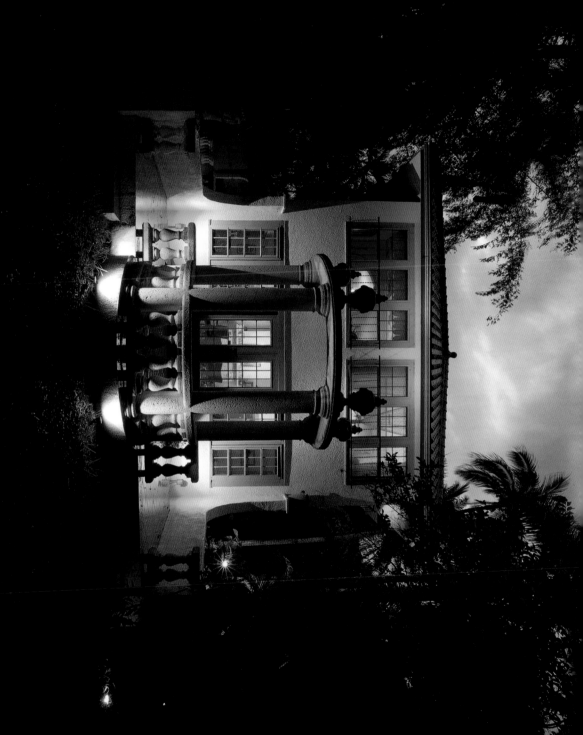

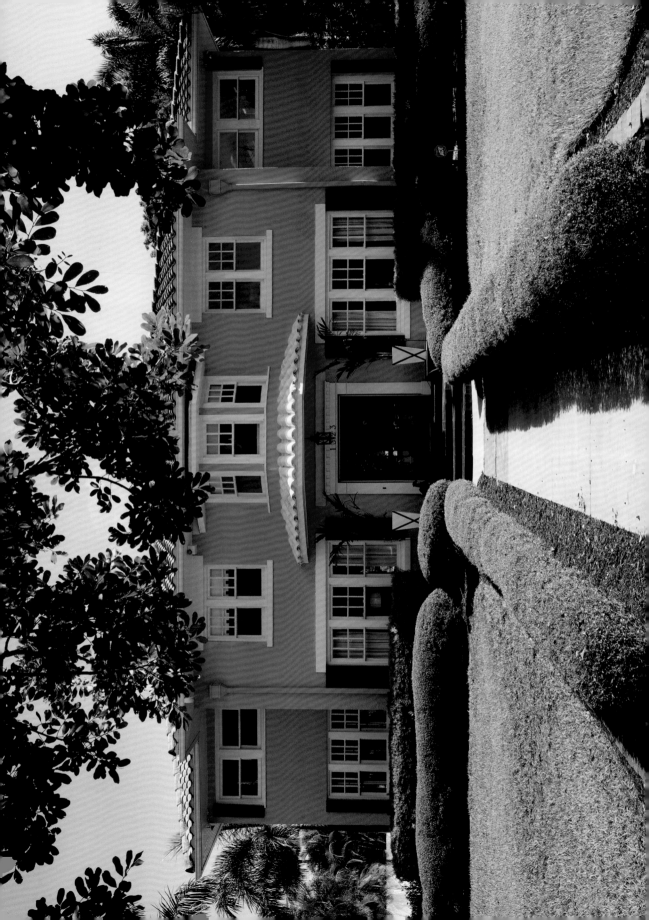

3

Pink Lady

1323 Gasparilla Drive

THIS HOME IS EASILY IDENTIFIED as a large version of the Gordon Van Tine kit 535, or Roberts model. The inclusion of two-story side bays used as porches or sunrooms provides the certainty. The design clearly follows the Mediterranean or Spanish influence with its barrel-tiled roof and smooth stucco finish.

Floridian influence is illustrated by the choice of white tiles, which minimize the heat absorbed by the substantial roof. The flamingo pink paint color is fitting for a life in paradise. Double front doors with detailed glasswork add to the strong sense of place the property maintains on this prominent street. Though the home has had extensive additions on the rear since it was originally completed in 1930, it retains its remarkable historic character.

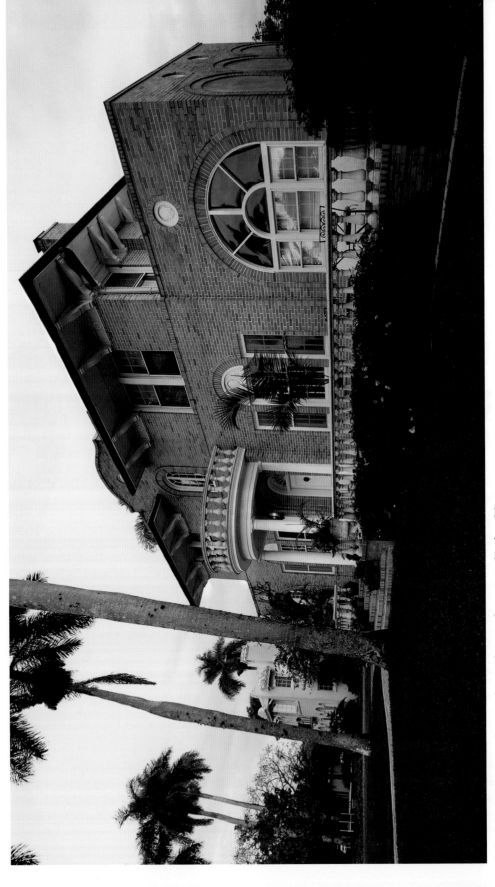

A Greek Revival expresses the 1920s boom. Photograph courtesy of Andrew West.

4

Parker-Klingerman-Mertz House

1252 Caloosa Drive

BUILT WITHIN the Riverside Subdivision, this Caloosa Drive home is evidence of the affluent housing envisioned for the neighborhood. The wealth spent by the financially successful early owners to create the Roaring Twenties neighborhoods is well demonstrated.

This formidable house still commands as strong a presence as ever. The primarily Italian Renaissance style with Greek Revival features is atypical for Southwest Florida at the time, and a rarity in Fort Myers.

The home's prominent exterior design elements are created by the repetition of symmetry with the massive buff brick exterior. A hierarchy is created from the ground up. The elegant raised terrace extends a welcoming nod. Originally believed to have had ironwork railings, the existing concrete balustrades maintain a stately feel and frame the centered formal semicircular portico entry. The door is surrounded by decorative elements: a fanlight, patterned brickwork, and columns that make for a grand arrival.

Arches and detailed wood trim are used extensively in the window elements,

reinforcing the formality. The home's strong central features are balanced with the symmetrical sides, including the large first-floor triple Palladian windows with rowlock surround that matches the brick detail flanking the entryway.

The second-floor fenestration is symmetrically composed and includes double-hung paired windows. A center-arched casement window provides a transition to an inset medallion and the decorative brick parapet detailed with a slight arch placed directly above.

Capping the front façade is a tiled hipped roof. The substantial cornice and heavy eave brackets draw attention to the length of the front while providing a horizontal contrast to the dominant vertical features.

The elegant wing sections are slightly set back. The eastern side is the original porte cochere with an arched entry and repetitive brick detailing of the character-defining elements. The western wing replicates the style with a large arch and wood trim, with another decorative medallion atop. Originally an open-air porch, this space is now an enclosed sunroom. The brick trim that caps both wings continues as a belt course along the main section of the home, signifying a separation of the first and second floors while tying the levels together.

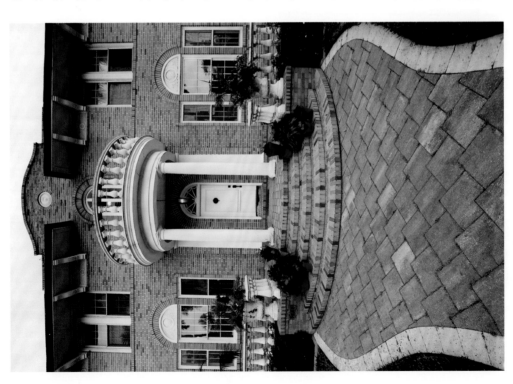

A variety of classic components creates the entry portico. Photograph courtesy of Andrew West.

The formal living room.
Photograph courtesy
of Andrew West.

Originally built for J. R. Parker, the house was designed with sixteen rooms, which were not finished on the interior until several years after construction. Dr. John Klingerman, a prominent local urologist, later purchased it. It is from these longtime owners that the home is still referred to as the Parker-Klingerman home.

Today, Corey and Suzy Mertz, along with their children, have lovingly called it home since 2006. Suzy, a native of Fort Myers, recalls growing up in the surrounding McGregor Boulevard neighborhood and has long appreciated the house. The Mertzes' journey to Caloosa began with a search for a home with a bit more space for the young couple. This home appreciatively met their mission.

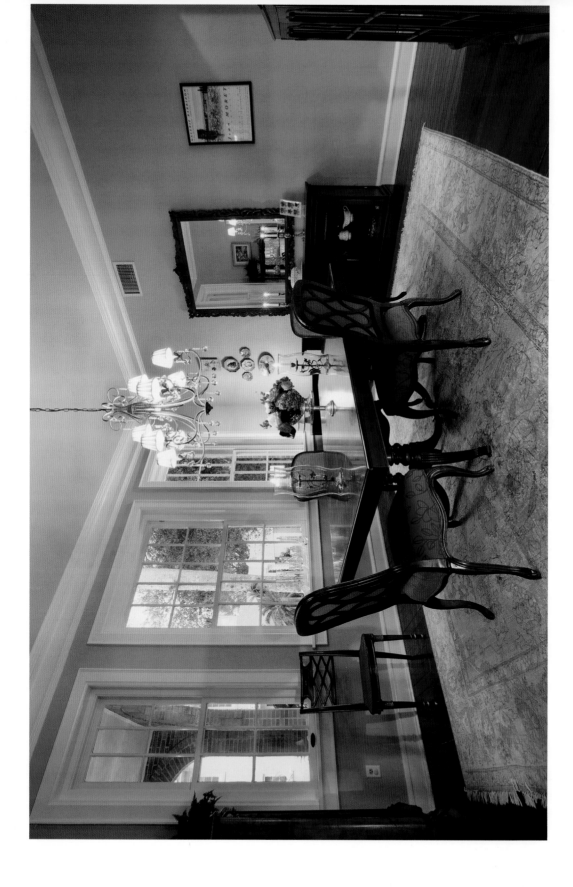

The interior retains a sense of solidity. The continuous run of large windows allows natural light to flood into the entire house, while the eleven-foot ceilings emphasize the grand scale. Formality is expressed through the large moldings and plaster ceiling-light medallions, as well as the stately fireplace and staircase. The original wood floors, doors, and fixtures, along with many of the early finishes, remain in place, providing a sense of the original appearance.

Complementing the fixed elements of the home are the paint colors, furnishings, and artwork that Corey and Suzy selected in staying true to the prevailing style. From the formal living room and gracious dining room to the informal reception hall, the house is simply elegant.

With a growing family, Corey and Suzy saw the opportunity and need to make some changes. The most significant project to date has been a dramatic kitchen remodel. Combining the original kitchen, breakfast room, pantry, and workspace into one large room has given the family a contemporary, functional new space within the flow of the historic house.

Future plans include continued custom design styling of the enclosed porch, as well as replacing the existing bathrooms. A rear garage and apartment likely built at the same time as the main house, or shortly thereafter, may be used to meet additional living needs. As a forever home, the Mertz family enjoys and appreciates their historic Caloosa Drive house.

5

Quaint Tudor

1427 El Prado Avenue

HAVING RECENTLY WED and settled into an Asheville, North Carolina, home more than a century old, Brent and Florence Crawford had mixed emotions when he was offered a corporate promotion requiring relocation to Fort Myers. While driving along the corridor during his first visit to Fort Myers, Brent, a self-described "historical romanticist," stumbled across an aging, eclectic Tudor home for sale. This encounter helped him make a life-altering decision.

A tour of the neighborhood by Florence a week later confirmed the pair would be moving. As with many who are proud to call the McGregor corridor home, it was the charm and eclectic mix of houses that compelled the young couple to establish new roots.

Constructed in 1925 within the Carlton Grove development, the house features the dominant steeply pitched front-gable facade and scaled matching entry that most strongly reflect the Tudor influence. Supported by the large side-gabled wing and situated in the center of three lots, the home maintains a strong street frontage. The subsequent enclosure of both shed dormer-side

OPPOSITE: *Steep gables identify the Tudor style. Photograph courtesy of Andrew West.*

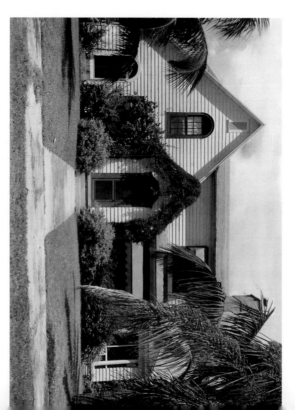

Early days of the quaint Tudor. Photograph courtesy of Brent Crawford.

porches by the Crawfords further enlarges the front massing.

Noticeably absent from many South Florida Tudor homes are the brick, stone, or exposed timber elements commonly used on the traditional medieval English period homes as seen in the North.

At this time, the lack of practiced northern architects within South Florida enabled loose interpretations of architectural styles by local and regional architects, designers, and builders. This home is an example of that,

and of the use of readily available local materials in finishing the structures, as seen in the wood lap siding and a cost-effective asphalt shingle roof. Detail features, such as the Colonial Revival–style pediment and flanking pilasters surrounding the front door, add to the eclecticism. A ¾-height elevated door on the western edge of the front facade that opens onto a vestibule adjacent to the dining room is an eye-catching curiosity.

Over two thousand square feet, the main house features three bedrooms, two and one-half baths, formal

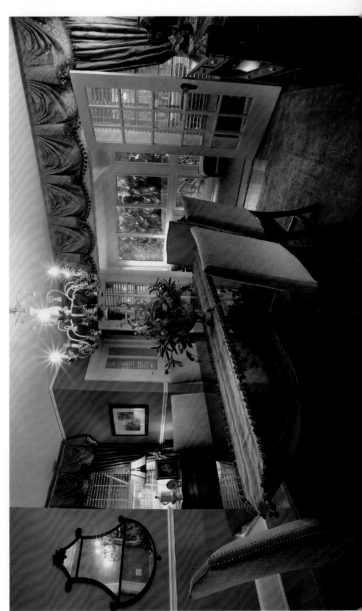

The antique dining table used for formal family meals. Photograph courtesy of Andrew West.

living and dining rooms, a den, a kitchen, and working areas. Knowing this was to be their home for many years, the Crawfords set about ensuring that fundamental parts met current codes and were long lasting. Recent work includes new electrical, plumbing, and HVAC systems,

as well as reconstructing several crumbling plaster walls. Brent and Florence simultaneously worked on restoring or refinishing historic elements such as the original wood floors, moldings, and characteristic features.

Projects continued as the needs of the growing family

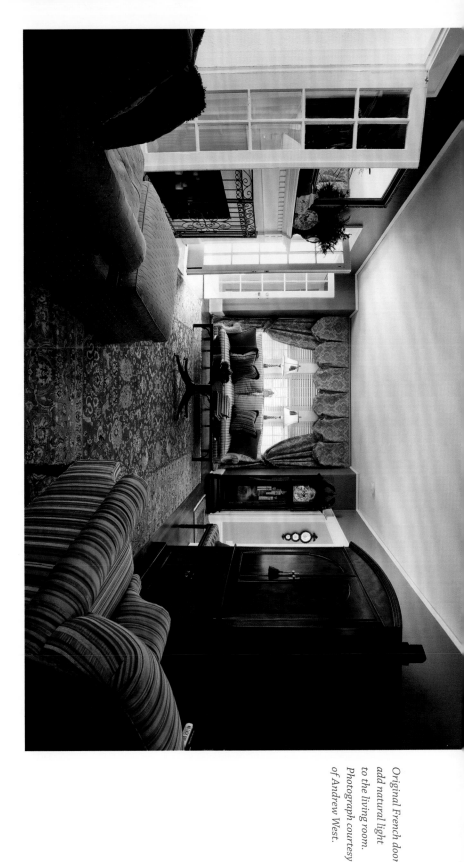

Original French doors add natural light to the living room. Photograph courtesy of Andrew West.

The existing rear carriage house with an apartment above, built in 2007, replaced an original carriage house and apartment in the same location that had suffered deterioration beyond repair. It is uncertain if the original was built to meet the needs of an extended family or as an office for an early owner said to be a doctor. These two structures

evolved. Work on the main house included enclosing both side porches while respecting the original size and layout. A new kitchen and new bathrooms were completed in 2009 within the overall footprint of the existing space. Moldings and detail elements not salvageable during renovation were replicated to maintain the style.

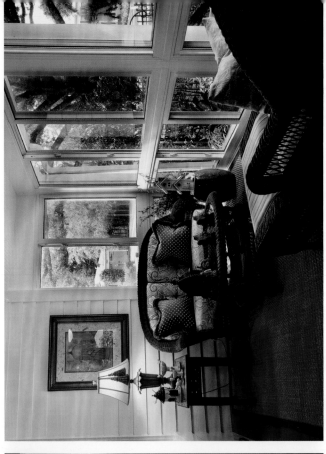

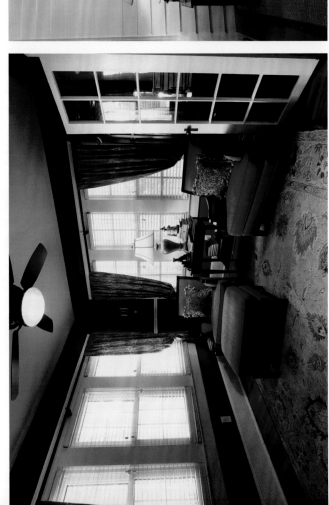

LEFT: Oversize comfy furniture outfits the den. RIGHT: An enclosed porch provides a spot for a cool fall day. Photographs courtesy of Andrew West.

BOOM AND BUST

combined, with the carriage house reconstructed to match the general character of the original building and the main house, work to create a large and flexible home.

By 2012, three young children prompted family playtime to take a higher priority. Added were a large pool, well-designed outdoor living areas, and shaded gardens.

This Tudor gem experienced significant changes for more than a decade after the Crawfords' purchase. Respect

of the historic house, and understanding how it could evolve as their family did, guided the Crawfords through considerate and thorough design decisions. Although the new construction is evident at close view, it blends seamlessly with the historic building. The level of care and maintenance of the property is meticulous. Thoughtful details, from an iron mailbox to the prominent front awnings, continue to add to this Tudor's timeless character.

6

Porch-Centric Bungalow

1463 Poinciana Avenue

THIS CRAFTSMAN BUNGALOW is located in an area where numerous sales and subdividing of the original property in the 1920s ultimately culminated in two neighborhoods being developed at the same time, yet with very different intents. The affluent Edison Park is situated on the north side. Poinciana Park, on the south side, is lined with mature oaks shading houses in an array of styles. Homes in the welcoming neighborhood were built and sold quickly. Despite the smaller sizes and costs, the designs followed trends that have proven to be timeless.

True to the fundamental Craftsman bungalow profile, this 1925 house draws its character from the repetitive use of contrasting horizontal and vertical design elements. Shallow pitched rooflines create a broad structural form. A full-width gabled porch bound by a solid rough-faced stone balustrade continues the linear flow. The same stone treatment covers the piers carrying the battered-shape columns exemplifying a strong vertical quality. The horizontal lines of the stone cladding, as well as the pier and column caps, add a visually contrasting effect. Original windows with the characteristic vertical three-over-one double-hung sash further accentuate the horizontal roofline.

Approaching the broad front steps, one develops an appreciation for the craftsmanship.

Many striking original carpentry elements remain intact: window frames and matching screens, the multipaned front door, bead-board porch ceilings and eaves, exposed rafter tails, and decorative braces.

Originally a small-scale structure with a functional layout, this house has been gently adapted and expanded over the years to meet the evolving needs of the families who have called it home. Much of this was done by longtime Lee County Public Works director Jim Lavender and wife, Sherry, who occupied the bungalow for forty years. During the 1980s, they increased the living space by enclosing the east side of the wraparound porch, and added a family room with a screened patio and a master bedroom/bath suite. They also built a two-car garage.

The Lavenders' respect for historic integrity led to sensitive design decisions as changes were made to the home. Importantly, the rear additions are not visible from the front facade. Similar rooflines and finish materials blend the newer construction with the original home, while modestly differentiating between the old and the new with deliberate use of best preservation principles.

Gary and Heather DeMarinis moved to Fort Myers from Tampa, Florida, and purchased the home as new-lyweds in 2010. Heather shares that after considering options in the area—a beachfront oasis, a gated community, or a historic home—the third choice prevailed. They knew immediately upon walking into the house that it was for them. The bungalow had the character Heather was looking for in the cracked tile porch, the lead glass windows operated on weights and pulleys, the original trim work, and the Dade County pine floors. And the large rooms, combination of indoor and outdoor living space, and large backyard that would be perfect for the couple's dog to enjoy met Gary's requirements.

Though they fell in love with the house from their first visit, the DeMarinises had plans to create "their home." Although a task list was in hand, the pair found humor in the first and unexpected project, relating to the mailbox. Unbeknownst to them, the Lavenders had been grandfa-thered into the old-fashioned system of mail being hand-delivered to the box mounted next to the front door, since eliminated for new homeowners.

With the installation of a mailbox at the roadway, the couple's journey began. They quickly learned what they could and could not do themselves. Today, their touches appear in the restored pine floors that had been buried under layers of tile and linoleum, the replacement of the damaged clam shell moldings and trim pieces, and fresh paint throughout.

The remodeled kitchen closely resembles the original style. Photograph courtesy of Andrew West.

The DeMarinises did major remodels of the kitchen and the master bathroom. Though they felt that most of the existing kitchen should be removed due to the irreparable condition, an original built-in cabinet was kept and established the design concept for the project. The master bathroom received a complete makeover, with a walk-in shower, penny-round tile floors, and a freestanding vanity that more closely fit the craftsman motifs than previous alterations.

The interior design reflected the DeMarinises personal style and was well suited to an older home. On display were many of the family heirlooms Heather had collected over the years. Certificates and photographs dating back generations were placed throughout. Fishing and hunting memorabilia belonging to Heather's grandfather accented the rooms. Her grandmother's vintage living room furniture was not just for looks but was a functional part of everyday living. Shabby chic touches included a light

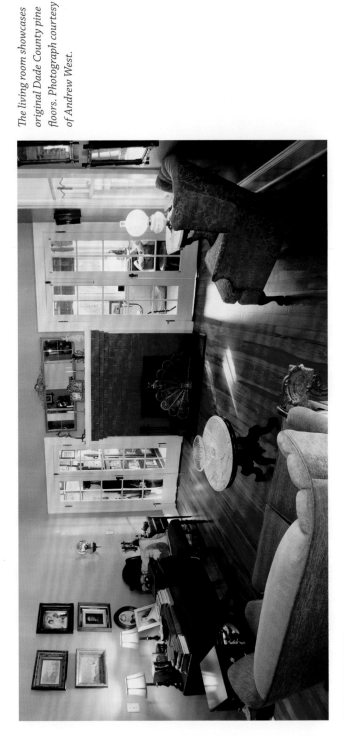

The living room showcases original Dade County pine floors. Photograph courtesy of Andrew West.

fixture Heather made from an old hay trolley and lamps purchased from her favorite vacation spot, Key West.

While the couple created their vision inside the house, they witnessed an unanticipated part of Poinciana Park life outside as the neighborhood unfolded in front of them. Gary and Heather would take their golf cart or bicycles or walk downtown to spend the evening. Heading the few blocks to the Caloosahatchee to watch the sunset, fish, or paddleboard was common. Most important, they discovered that their neighbors are, as Heather says, "Fantastic!" Poinciana Park is a close-knit community where everyone respects each other's privacy but no one is a stranger. From the scheduled block parties and holiday celebrations to impromptu pizza parties and evenings spent on the porch with neighbors, it was truly a place to call home.

Though Gary and Heather have now sold their home and moved away from Fort Myers, they cherish their memories of this Poinciana bungalow. The time spent on the front porch or rear enclosed patio watching football, taking naps, playing with the dogs, and visiting with neighbors were engaging porch culture experiences. Since air-conditioning became common in the late twentieth century, the garage has replaced the porch as the dominant feature on many contemporary homes, lending to

the demise of the qualities of front porch life. Poinciana Park proves the tradition is alive and well with an invitation to sit a spell.

A place for porch culture to thrive. Photograph courtesy of Andrew West.

7

Casa Rio

2424 McGregor Boulevard
(and 2430 McGregor Garage / Servants Quarters)

THE WEALTHY NORTHERNERS who built grand homes and enjoyed high-society winter seasons during the Roaring Twenties in the growing communities of Palm Beach, Coral Gables, and Coconut Grove on Florida's east coast are well known. Others chose the City of Palms for a more subdued winter retreat before returning to the business and social demands of their northern lives. Paper magnate Charles Stribley became one of the latter when he developed his Caloosahatchee riverfront estate in 1925.

An inventor, Stribley and his associates at Thilmany Pulp and Paper Company made millions as the paper industry flourished in the Fox River Valley of Wisconsin in the early twentieth century. The company produced waterproof wax paper for military use during World War I. Stribley was involved in perfecting the process for making wax paper for general use and for developing a watermarking technique.

Settling in Kaukauna in 1910, Stribley built a home influenced by the Craftsman bungalow and designed by Milwaukee-born and -based architects Henry Van Ryn and Gerrit de Gelleke. Their highly profiled buildings are found throughout Wisconsin and include

Boscobel High School, the Hudson Public Library, and numerous residences. Many of their works are listed on the National Register of Historic Places.

The only known example of Van Ryn and de Gelleke's work outside Wisconsin is this grand 1925 Spanish Colonial Revival–style seasonal residence of Charles and Emily Stribley in Fort Myers. The house is listed on the National Register and has been designated a City of Fort Myers local historic landmark.

After visiting in 1920 upon the invitation of Thomas Edison, Stribley purchased a mucky lot in 1923 on the Carson property, just south of the Edison and the Henry Ford properties. Stribley soon brought in another new friend to work on his project, J. L. Lofton.

Lofton dredged and filled to construct the historic boat basin in downtown Fort Myers. As part of the process, he was able to make an island for himself in the Caloosahatchee River, still intact today. He built a home on the island and lived there long enough to obtain squatter's rights. He sold his piece of paradise, Lofton Island, in 1948. Lofton brought his dredge machine, which he apparently named after Stribley, down the river from town to create a home site for the industrialist's winter retreat.

From McGregor Boulevard, the gracious estate comes into view through a set of entry gates leading down a four-hundred-foot driveway lined with royal palms, mimicking the iconic landscaping along the boulevard. Florida's tropical environment proved ideal for architects to adapt the trending design elements found in Spanish missions in California and New Mexico. Van Ryn and

Casa Rio was awarded a National Register of Historic Places designation in 1996. Photograph courtesy of Andrew West.

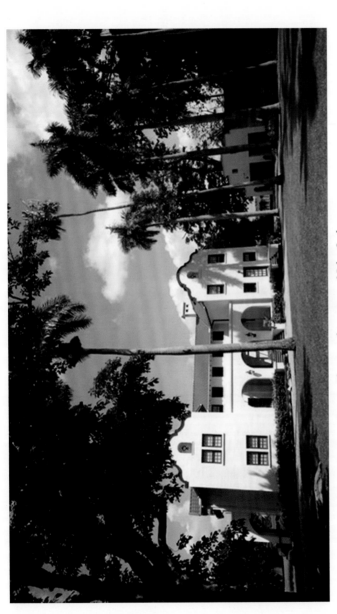

The paired parapets reflect a Mission influence. Photograph courtesy of John Carbona.

de Gelleke created an impressive example with the aptly named Casa Rio, or River House.

The elevated two-story structure features a central mass flanked by side wings forming a symmetrical H shape. A one-story arcaded courtyard faces McGregor, with trellises creating shade. Discernible Spanish Mission influences include smooth stucco walls and chimneys, tiled gable roof forms with widely overhanging eaves braced by ornately capped parapet walls, roman arched openings, wooden French doors, six-over-six and three-over-three double-hung wood sash windows, and paired bell towers.

Casa Rio's 4,875 square feet of living space includes

living and dining rooms featuring seven glaze-tiled fireplaces, an expansive kitchen and butler pantry, five bedrooms, four and one-half baths, and adjacent covered and open exterior spaces. Cross-sawn heart pine floors and high plaster ceilings grace interior spaces.

In addition to the interior design, the equally impressive outdoor living spaces make Casa Rio a recognized landmark. While automobiles were becoming commonplace in the 1920s, many prominent residences along the Caloosahatchee River were still designed with a waterway orientation. The river side of Casa Rio is a significant example of the lasting importance of water transportation in Southwest Florida.

The waterfront facade is wrapped by a deep loggia, which projects from the building, creating an open sundeck overlooking the river from the second-story level. French doors lead to the terrace and sundeck.

The grounds were initially influenced by the Edison and Ford estates. Species brought from around the world created an exotic garden. The Stribley boat basin is akin to one located along Ford's waterfront.

The estate originally encompassed 3.3 acres, including a separate garage with servants quarters to the south. Casa Rio had several owners after Charles Stribley's

LEFT: Original 1920s living room. Photograph courtesy of John Carbona.

BELOW: Contemporary room. Photograph courtesy of John Carbona.

restoration of all fenestration, concrete repair, a new roof, and the addition of freestanding amenities.

Modern ceramic tile was removed to reveal the original pigmented concrete exterior decks. All of the original windows and doors were repaired, reglazed, and painted as needed. Matching metal roof tiles and replicated gutters and downspouts replaced the modern varieties installed over the past fifty years. The plumbing, electrical, and mechanical systems were updated while maintaining the historical integrity of the resource. During construction, extensive structural damage was discovered and rectified.

A new freestanding garage building was located to the

Once a garage and servants quarters, this is now a private home. Photograph courtesy of John Carbona.

An aerial view of the estate. Photograph courtesy of John Carbona.

tenure ended in the late 1940s and the property was divided in the 1950s. By the time John Carbona purchased the home in 2000, the building had numerous inappropriate additions and was in dire need of care.

Carbona hired local Ferrell Sanford Studio architects for a major historic restoration project that took two years and cost two million dollars. The project included the removal of garage and shed additions, the complete

north, forming an entry leading to a new poolside cabana with kitchen and bath, shade trellis, pétanque courts, and garden spaces. The pool, built in 1999, was modified to reduce the size of the pool deck and add a low surrounding wall to create a landscape area that transitions to grade level forty-two inches below. The well-fed deep-water pool now features a vanishing edge facing the river. The original boat basin was also restored.

When John Carbona is asked about his riverfront gem, he shares an expansive and expressive journey into the past. He is the epitome of the proud owner of a historic home.

The infinity pool is a trendy addition. Photograph courtesy of John Carbona.

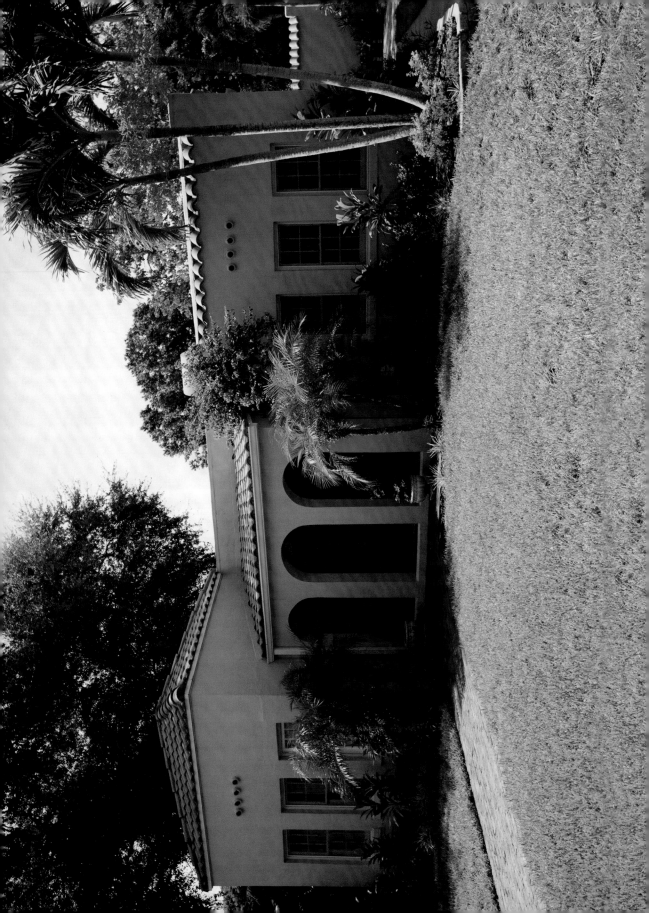

8

Simple Spanish

1424 Linhart Avenue

THIS INVITING ECLECTIC RESIDENCE conveys an array of features reflecting its 1920s Spanish influence. Minimal in detailing, interest derives from the varying asymmetrical components creating its form. Repetition in threes defines the front facade.

The triple rectangular windows, slightly recessed triple-arched front porch distinguished by an arcaded loggia, and the triple rectangular windows in the furthest setback section lend a formality to the front of the home.

The roofs displaying a hipped shape on the right section, the shed covering the porch, and the parapet behind beg for attention as well. Spanish elements such as the stucco finish, barrel-tile roof, and tile accents complete the stylish residence. Noticeably absent are the traditional overhanging eaves and decorative trim. The existing simple, manicured landscape is well matched to the original character gracing the home.

OPPOSITE: *Varying barrel-tile rooflines add dimension to this casita. Photograph courtesy of Andrew West.*

9

Judge's Rule

1308 Almeria Avenue

FLANKED BY TWO modest secondary wings, the central two-story component of this historic home possesses great prominence on a corner lot. Built toward the peak of the Florida land boom, this home projects the wealth and desired affluence that developers were seeking to entice to the City of Palms. It is a wonderful example of understated Old Fort Myers elegance, even without many of the more elaborate ornamentations commonly found in the Mediterranean Revivals of the 1920s, let alone in this neighborhood.

With sparse embellishment to divert attention, the height and shape of the central section of the house clearly stand out, emphasizing its simple form. In contrast, the arched feature, as well as the door with paired battered supports, anchors the facade to create an inviting entryway. The Mediterranean influence is easily recognized by the stucco finish, barrel-tiled roof, and numerous arched windows.

The visible flat roof with a parapet on the west wing and oversized arched windows add character. This section likely served a dual function. Directly facing the Caloosahatchee, the graceful large windows were ideal for allowing river breezes to sweep through the ground floor of the home in warm summer months. And facing the afternoon sun, on cool Florida winter days the windows would have helped capture additional heat.

Battered supports frame the arched entry. Photograph courtesy of Andrew West.

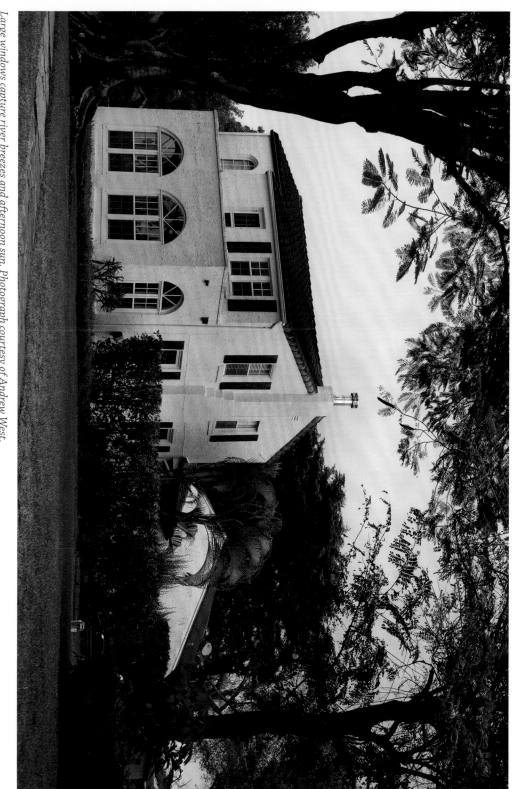

Large windows capture river breezes and afternoon sun. Photograph courtesy of Andrew West.

The east wing originally served a more utilitarian function as well. It was built as a two-car garage connected to the main house by a breezeway. According to the story, former owner Mrs. George Whitehurst had it converted into living quarters for a son-in-law after World War II.

Ownership records show numerous transactions before the nearly thirty-year Whitehurst tenure began in 1944. George W. Whitehurst Sr. and his wife, Myra, came to Fort Myers in 1923 to continue George's legal career. In 1916, two years after completing law school at the University of Florida, he was elected as judge of DeSoto County. Judge Whitehurst spent the next fifty-four years as a public servant, including terms as a circuit judge from 1918 until 1947, when President Harry S. Truman appointed him a federal judge. It was during these years of important community service that the couple and their three children occupied this Almeria Avenue home.

Judge Whitehurst, later remembered by former law school chum and prominent Fort Myers attorney Lloyd Hendry, was "known for his fairness, temperament, and uncommon good sense." He subsequently became a driving force in converting the stately 1930s post office into the federal courthouse in 1965. In honor of Judge

Whitehurst's commitment to his field, in February 1984, nearly ten years after his death, the courthouse was officially renamed the George W. Whitehurst Federal Building and United States Courthouse.

The Whitehurst family sold the home in 1971. The couple that purchased the house was enamored of wallpaper and owned a local store called Wallpaper World. Current owners Jim and Diann Seals note that wallpaper was installed on nearly every interior surface, including the master bedroom ceiling. Diann not so fondly recalls the laborious hours that she and Jim spent, oftentimes with friends, trying to remove stubborn wallpaper from the original plaster walls.

Like the Whitehursts, Jim and Diann also came to Fort Myers for career and family. The two couples' lives share many parallels. Jim, also a University of Florida Law School graduate, was a college friend of Wilbur Smith. Smith is a Fort Myers native, prominent local attorney, and former mayor of the City of Palms. Smith invited Jim to join his law practice. After starting his own firm, Jim was elected a Lee County judge in 1980, and then appointed a Circuit Court judge by Governor Bob Graham two years later. After thirty years of service, Jim officially retired from the bench. Diann, a cardiac nurse, has had

the opportunity to be within a large medical community, also resulting in a long career in Fort Myers.

By the late 1970s, after being in the area for several years and with the demands of their family changing, Jim and Diann saw the need to move from their suburban Lee County home into the city. Largely to reduce the time spent driving children to and from their school and activities, they saw the charm and benefit of living in historic Fort Myers, as well as the convenience for Jim to be close to the regional legal center.

Besides being closer to downtown, the couple had two other requirements of their new home: two stories and uniqueness. Although they did not intend to buy a house that would be all-consuming of time and of finances, that

The paint palette softens walls once covered in wallpaper. Photograph courtesy of Andrew West.

is exactly what happened. Despite their friends and family taunting them as being foolish, in 1979 Jim and Diann embarked on several years of restoration and rehabilitation. Stripping wallpaper remains at the forefront of their memories.

By the time the work was done, the Sealses had created their dream home. And, as Diann remembers with laughter, the project emptied their wallet. Though much

of the work was necessary to bring the aging home to its original condition, the final cost of work was three times the original purchase price.

Diann believes the home has been adapted to create a comfortable space for their family, and the Sealses agree that their lifestyle is defined by their home. For over thirty years they have enjoyed sharing their home with family and friends, in recent years particularly for wedding and baby

showers. They are proud of the décor and are pleased with the uniqueness of their home and its adaptability to uses.

A rear garage addition and driveway redesign, the renovation of the previously converted garage, the enclosure of the connecting breezeway, and a modest expansion of the dining room to a rear terrace have all made the home more functional. For practical purposes, the kitchen and bathrooms have been remodeled within the existing footprints.

The location has been as important as the home itself for the Sealses. Diann appreciates the view of the river. The large corner lot with an open river view has been an extra bonus, acting as an extension of the home. The landscaped yard is another labor of love for Diann. Although the home is not a riverfront lot, the adjacent neighborhood park on the Caloosahatchee provides access for recreation on the water and is one of the Sealses' favorite places to stroll or enjoy an impromptu picnic.

After taking in the river views then passing through the graceful front entry to an open staircase with sunlight streaming through the arched window, the visitor might follow the view down the corridor to the wood-encased fireplace in the formal living room and be reminded of the unique history and character embedded in this home.

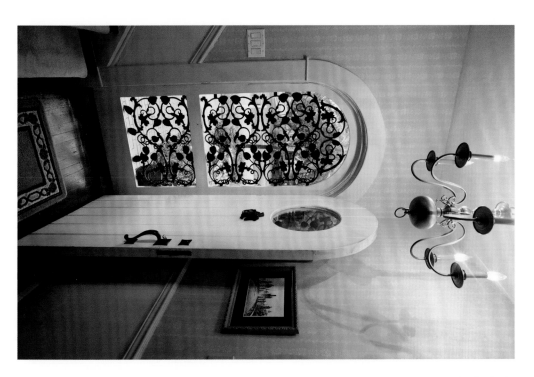

A whimsical screen complements an original wood door. Photograph courtesy of Andrew West.

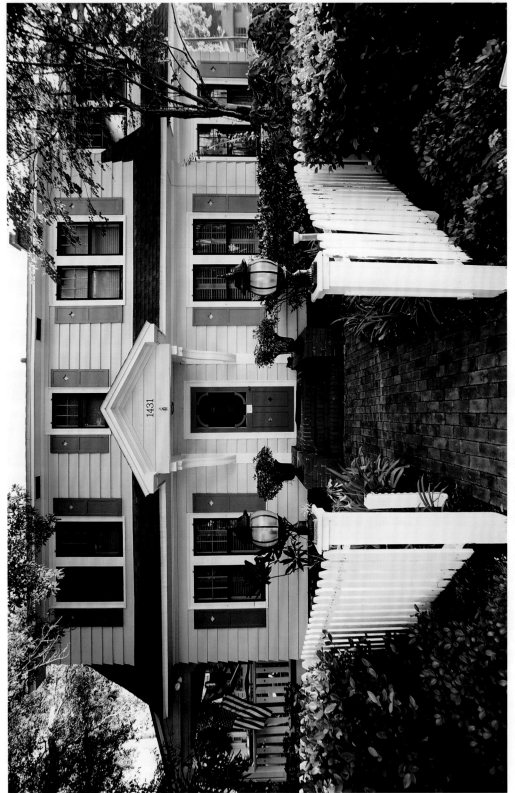

A white picket fence maintains the once rural neighborhood feel. Photograph courtesy of Andrew West.

10

Flying Dutchman

1431 Jefferson Avenue

THIS DUTCH COLONIAL Revival–style home is unique in Fort Myers and is one of a handful built in the area during the 1920s. Earlier homes of the twentieth century constructed with wood exteriors were predominantly Craftsman bungalows, as widely seen in the Fort Myers Dean Park Historic District.

Characteristic features of the Dutch Colonial include the side-gabled gambrel roof with slightly projecting eaves and a prominent continuous shed dormer on the front and rear facades. Window placement is always symmetrical, with an accentuated central front entry. The entry to this home includes pilasters and a bracketed porch roof.

Original construction on the property included a two-car garage, later expanded to accommodate four cars, and a second-story apartment believed to have been added in the mid-1930s. The last addition to the garage structure was a side sleeping porch on both the first and second stories.

Documentation indicates that the original side sleeping porch on the main house may not have had a roof. It was added in the 1930s along with the porch enclosure, which created a year-round room off the formal living area. A second-floor porch was also added to

would field calls twenty-four hours a day for the resident doctor, and perhaps for the other doctors in the neighborhood as well. In later years it became a residence for the grandmother of the doctor's wife, and has subsequently been used as an occasional rental unit or for additional guest space.

The neighborhood, located in the designated Seminole Park Historic District, represents the once seemingly endless real estate boom and the subsequent growth of the 1920s Florida land boom. It was the vision of New York senator and businessman C. W. Stadler and represented what today would be referred to as a "high-end estate development." The neighborhood was a rural development adjacent to the historic Fort Myers Country Club and nearly two miles from the center of "town." Stadler saw this as an asset, and the development reflected the location by creating a parklike setting for the stately homes.

A large platted park and open spaces define the triangular development. The road network incorporates broad sweeping corners and defines oversize lots suitable for the most significant homes of the time. Lots typically extended the full distance between the front and rear streets, rather than having a shared, common rear lot line or alley. At the original platting from the peak of the

An apartment now occupies the onetime doctor's office. Photograph courtesy of Andrew West.

the rear, perhaps a replacement for the enclosed sleeping porch. The last significant modification to the structure was a shed dormer side porch in recent years.

The apartment adds a unique historical interest to the property. When the addition was completed, a well-respected local doctor, one of three in the neighborhood, owned the house. As the neighborhood was located outside of town, the original use for the apartment was as a modern-day call center. In fact, written history has it that it was occupied for many years by a husband and wife who

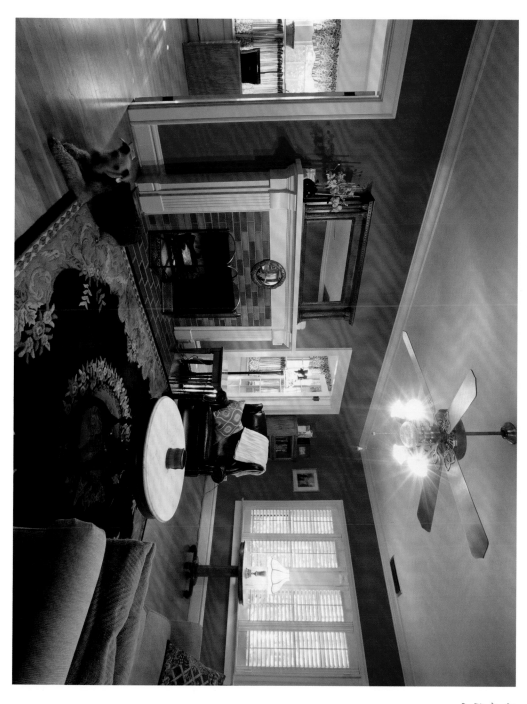

Sam, the family's Airedale, cozies up to the fireplace. Photograph courtesy of Andrew West.

Nearly every period of architectural style can be seen throughout the neighborhood today. Seminole Park has retained the parklike setting, its original street network, and large sweeping open spaces, including its most-recognized central park and large shade trees.

With nearly ninety years of history, 1431 Jefferson has been home to only three families, two of which claim more than two-thirds of those years. Built by lumber mill owner A. H. Draughn Jr. and his wife, Theresa, "Tee," of Fort Myers around 1926, it remained their home until about 1937. Draughn's profession as mill owner may have been one reason the couple chose to build a wood-clad Dutch Colonial rather than the more common stuccoed Spanish or Mediterranean Revival style prominent at the time.

In 1937, a physician and surgeon from Nashville must have appreciated the rural setting and purchased the property from the Draughns to be his new Fort Myers home. Dr. Bostleman was the third doctor to call Seminole Park, already established as a prominent neighborhood, home.

The move to Fort Myers proved successful for the doctor, not only in establishing his medical practice but also in meeting a young nurse. The doctor later

real estate boom in 1924, the neighborhood included only thirty-eight lots.

Stadler, harkening back to his northern heritage, envisioned large and typically Colonial Revival homes for the affluent neighborhood. He reportedly built several of the original homes within the neighborhood that served dual purposes: to set the standard for the size and character of homes to be built and to serve as overflow housing for northern guests.

Sadly, the timing for Seminole Park was off. During construction of the original series of homes, the Florida land boom came to a near screeching halt. The subsequent bust forever changed the development of both the neighborhood and of South Florida.

In a reactionary move, the replatting of the development in 1925 significantly reduced the lot sizes and increased the number of home sites available for sale. As the decades progressed, the lots were eventually sold and resold, some undergoing further division for resale, and the homes of the subsequent periods were built. Seminole Park today retains its early historic homes in remarkably fine condition and yet is a better visual example of the regional development trends over the past nine decades.

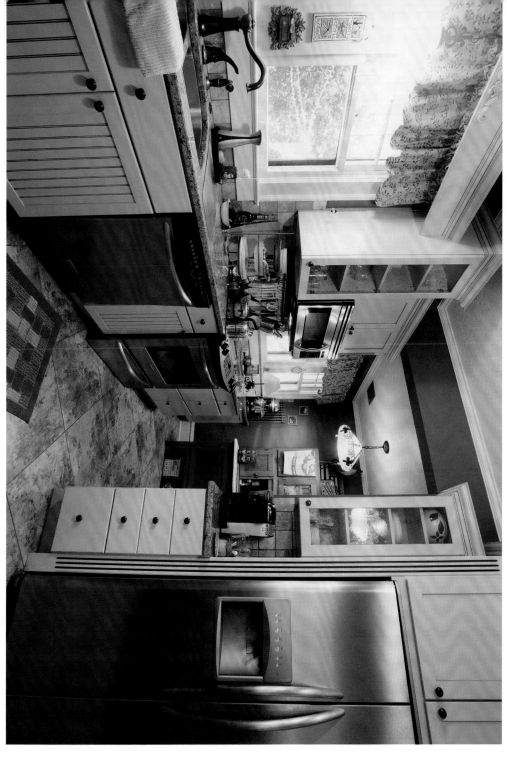

The current kitchen incorporates what was once a workroom. Photograph courtesy of Andrew West.

married Geraldine Duree, and the pair spent the next few decades raising their three children in the Jefferson Avenue home.

Geraldine, who had assisted the doctor full-time until the duties of motherhood shifted her focus, returned to her passion after the children were raised and continued to assist her husband until his retirement. Following her husband's death, Mrs. Bostleman stayed in the home until 1985. The property was then purchased and briefly held by a group of local investors until it sold again in 1986 to a young Fort Myers couple in search of a home to raise their two daughters.

Drawn to the unique architecture, parklike feel of the neighborhood, and proximity to nearby municipal attractions, Marc and Carol Yorkson needed no time to decide that this was the home for their growing family.

Although the decades have passed and there are no longer children playing throughout the spacious home and lawns, the couple still loves their treasure. The interior of the home has undergone renovation more than once yet has retained the character of its original layout and architecture. The side shed dormer porch, rear second-floor porch enclosure, and postcard-perfect back courtyard complete with koi pond and mature tropical foliage have been added by the Yorksons over the years.

As stewards, Marc and Carol were the driving resident forces in creating the Seminole Park Historic District, the fourth historic district designated by the city. Marc continues to be a longtime member of the city's Historic Preservation Commission, and Carol continues to act as resident liaison for the neighborhood, coordinating and hosting neighborhood watches and other activities.

OPPOSITE: *A traditional floor plan illustrates that open flow can exist in an older home. Photograph courtesy of Andrew West.*

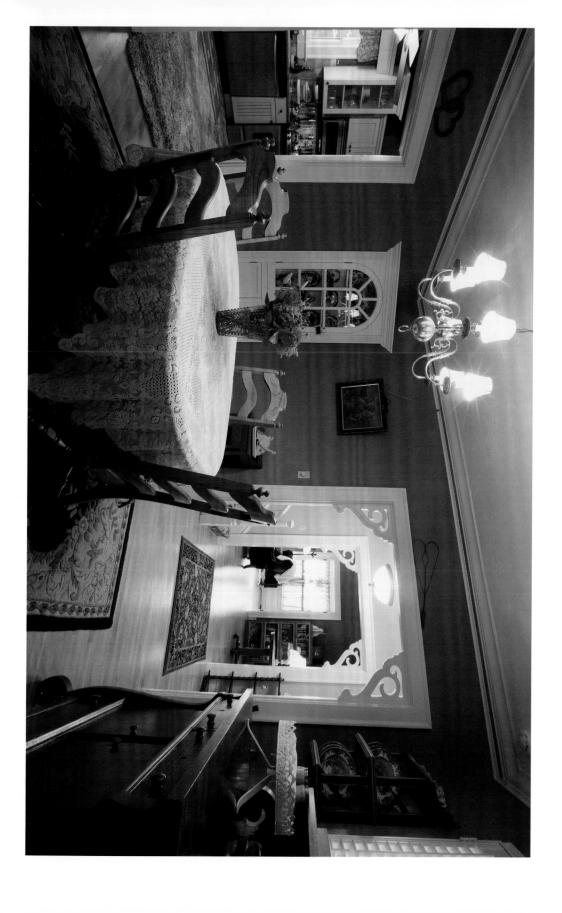

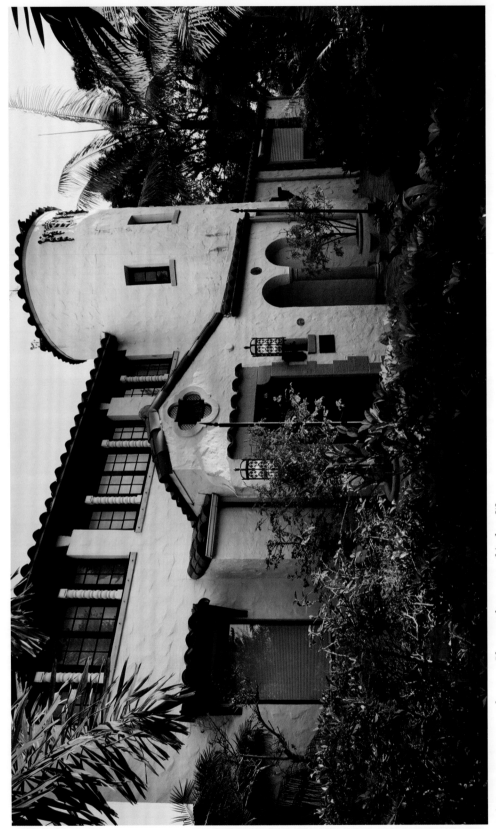

A dramatic entrance sets the scene. Photograph courtesy of Andrew West.

11

Dramatic Queen

1141 Wales Drive

AUSTRALIAN ACTOR H. ERIC JEWETT and his wife, Ada Wilhelmina, a New York heiress, purchased a roughly 1.5-acre Caloosahatchee riverfront property for five thousand dollars. Unaffected by Florida's economic woes of the late 1920s, the Jewetts were among the elite who continued to spend their wealth in pursuit of luxury and leisure. The couple succeeded in creating a grand winter retreat at Fort Myers.

The Jewett estate on the banks of the Caloosahatchee is nestled on a corner parcel within a quiet neighborhood. With nearly eight thousand square feet of living space, the property includes a main house, garage and servant quarters, pool and bathhouse, playhouse, elaborate courtyard, formal and informal lawns, and garden areas. Nat Gaillard Walker, a prolific regional architect, designed what would become one of the finest Mediterranean Revival homes in Southwest Florida.

The popular Mediterranean and Spanish Colonial Revival design trend that swept across the state in the early twentieth century is credited to Addison Mizner. Based in Florida's east coast city of Boca Raton, Mizner was one of the best-known architects during the 1920s boom period. His work is still widely seen throughout the South Florida landscape.

Tenets of Mizner's design philosophy were the use of construction materials suited for the subtropical climate, as well as creating spaces to maximize air circulation and light while minimizing summer heat. This practicality is expressed in the Jewett home in the irregular U-shape, the concrete with an aged stucco finish, the barrel-tiled roof, and a cornucopia of windows and doors. The result is a residence displaying endless architectural features that are functional as well as elegant.

A crenellated stucco wall that provides privacy for the interior lawn joins the main house and the bathhouse. The perimeter of the property adjacent to the streets is enclosed with a decorative lower wall of varying height and forms. Seen most prominently from the front facade is the circular two-and-one-half-story tower that anchors the southeast corner of the main home. Vertical stepped windows add interest and are suggestive of the circular staircase within. The tower is adorned atop with a decorative crest.

The remainder of the two-story facade is centered on an asymmetrical gabled entry, including a detailed quatrefoil window and sundial at the peak. A stepped quoin surrounded by an imbedded clay tile hood frames the stately front door. An arched, two-bay loggia connects this central section to the tower. Above, three sets of casement windows separated by twisted dividing columns, pecky cypress wood lintels, and concrete sills complete the facade. Set back from the formal front, the single-story wings further emphasize the height and prominence of the unique tower.

Turning to the side street, the significant scale, size, and thoughtful detailing are evident. Barrel-tiled pent eaves, original wood double-hung and casement windows of varying sizes, and three chimneys blend together as the structure extends to the original three-bay garage. Completed with a second-story servants quarters, the Mediterranean detail continues with an arched loggia entryway to the quarters above. The rear view reveals numerous and varying roof structures, heights, shapes, and building components, further illustrating the highly designed and expansive home.

The main house's interior is as impressive as the exterior, and stately Mediterranean Revival architectural features are apparent. The stylized living room guides the rest of the interior. The oversized central fireplace, beaded and stenciled beams, marbleized slab flooring, original moldings and niches, and numerous doorways access other areas of the sprawling home.

The living room, acting as the central feature of the

Bold layers define the owner's style. Photograph courtesy of Andrew West.

home, leads to the kitchen, informal dining areas, and formal dining room. The relatively narrow dining room creates a dramatic effect with its twenty-nine-foot-long span, chandeliers, formal table set for sixteen, and grand wall of French doors with half-circle leaded glass windows facing

the central exterior courtyard. Doorways also lead from the living room to the tower's circular staircase accessing the second-story game room and spaces within the wings.

Paired wings flank each side of the home and complete the pronounced U-shaped plan. A striking impression

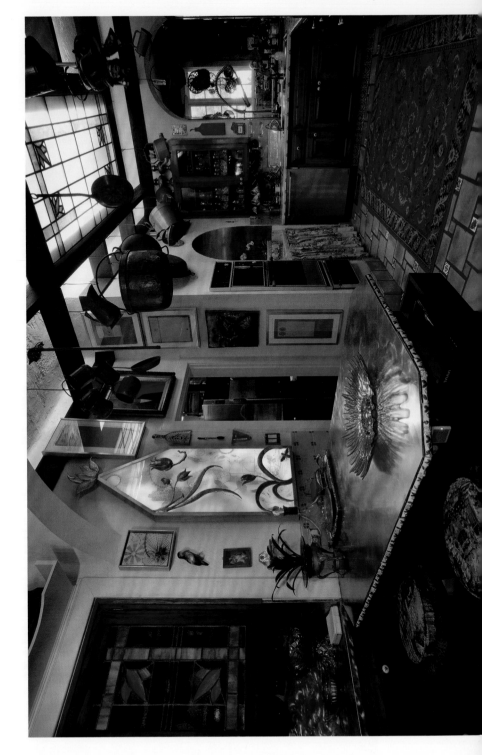

The family kitchen. Photograph courtesy of Andrew West.

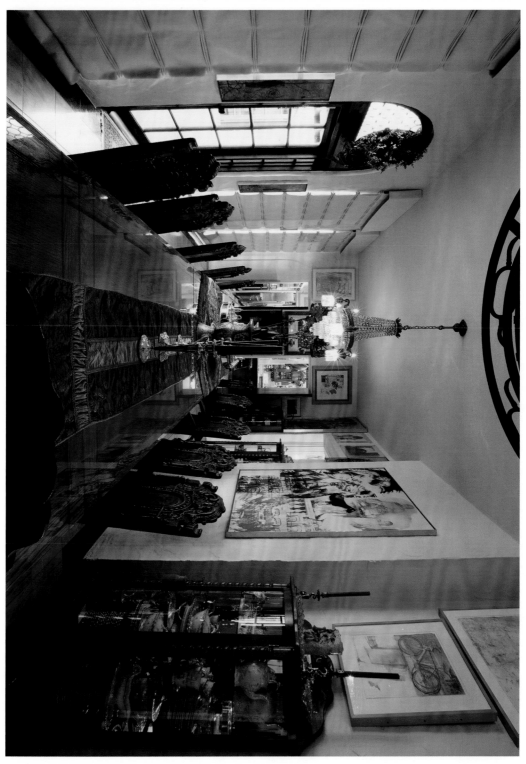

One of two formal dining rooms. Photograph courtesy of Andrew West.

bedroom, a unique fireplace anchors the center of the master bedroom. Detailed built-ins for personal treasures, chandeliers, trompe l'oeil paintings, and custom tiles are thoughtfully placed in these largely functional rooms. These elements emphasize the Jewetts' commitment to creating a masterpiece.

The same attention is given to the style of the outdoor living spaces. The courtyard, central fountain feature, and decorative walls are key components in continuing the finely crafted detailed experience. A charismatic two-story bathhouse lies beyond the courtyard perimeter wall. Said in early days to be the grandest in Fort Myers, the bathhouse includes a central staircase leading to an open-air second story. Flanking the center staircase to the upper level are his and hers changing/bathrooms decorated with whimsical marine-inspired tile. Defined by a series of arches and symmetrical hip-roof wings off the central rotunda, the bathhouse extends the strong Mediterranean influence, creating a captivating space for gathering and an amenity for the pool area.

Desiring an in-ground pool, yet challenged by the shallow water table, Italian craftsmen were brought over specifically to build the pool, one of the early artesian well-fed pools in Fort Myers. Rather than limiting the depth or

The tower's spiraling staircase. Photograph courtesy of Andrew West.

through the gallery-like halls is created along the courtyard lined with arches of windows and doors, including repetitive half-circle windows above. The arched features, which are practical in allowing air circulation and natural light to enter the space, contrast with the opposing solid walls ornamented with detailed moldings and artwork.

One wing includes two bedrooms and two baths, with access to the original garage and servants quarters building. The other wing contains a large gracious master suite, a dressing room, a private sitting room, his and hers bathrooms, and a multipurpose room. As in each

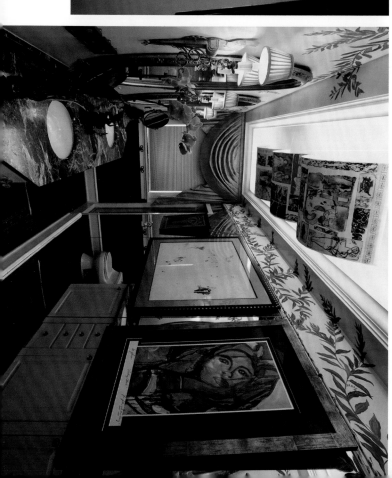

size of the pool by attempting an in-ground structure, the solution was to construct an oversize, aboveground pool. The objective was to elevate the surrounding landscape to disguise the aboveground appearance. The rear of the bathhouse creates the support of the earthen embankment that holds the pool structure. The hand-laid mosaic tile and a lush landscape emphasize the luxurious tropical retreat the Jewetts intended.

Another distinctive building on the property is the original party house, which matches the Mediterranean Revival style. Designed solely as an entertaining space, it includes a bar, kitchen, game area, and fireplace adjacent to the outdoor barbeque and patio with views out to the Caloosahatchee.

Numerous other features and elements dot the landscape: a combination of formal and informal gardens,

Best-known are their contributions to the development of Lee Memorial Hospital, today the largest public health system in Florida. In recognition of their commitment, the Jewett Wing of the original hospital on Cleveland Avenue was named in honor of Ada Wilhelmina. Unfortunately, the section was razed in 2005 to make way for a new expansion.

The Jewetts enjoyed their Florida home for nearly fifteen

tennis courts, and walls, including the Italian-themed "buried" walls, which are built to appear as if they have settled into the ground over the many years. The walkways and general landscape continue to add interest to this impressive estate.

Even as part-time residents, the Jewetts had a love of the community and supported numerous efforts.

LEFT: *Mosaic tiles, murals, and ironwork are used in even a small space. Photograph courtesy of Andrew West.*

OPPOSITE: *Craftsmen from Italy built the 1920s pool. Photograph courtesy of Andrew West.*

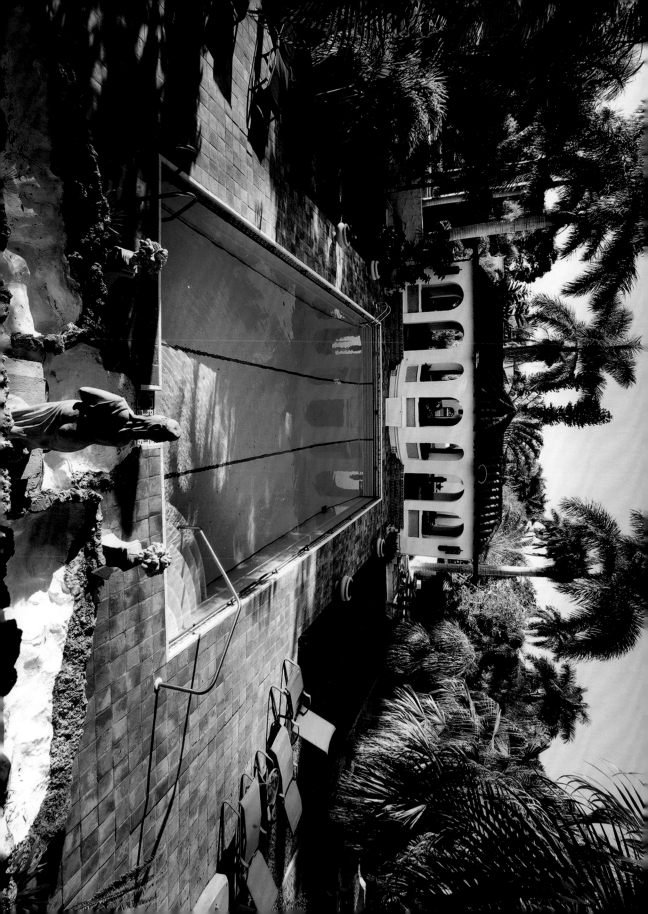

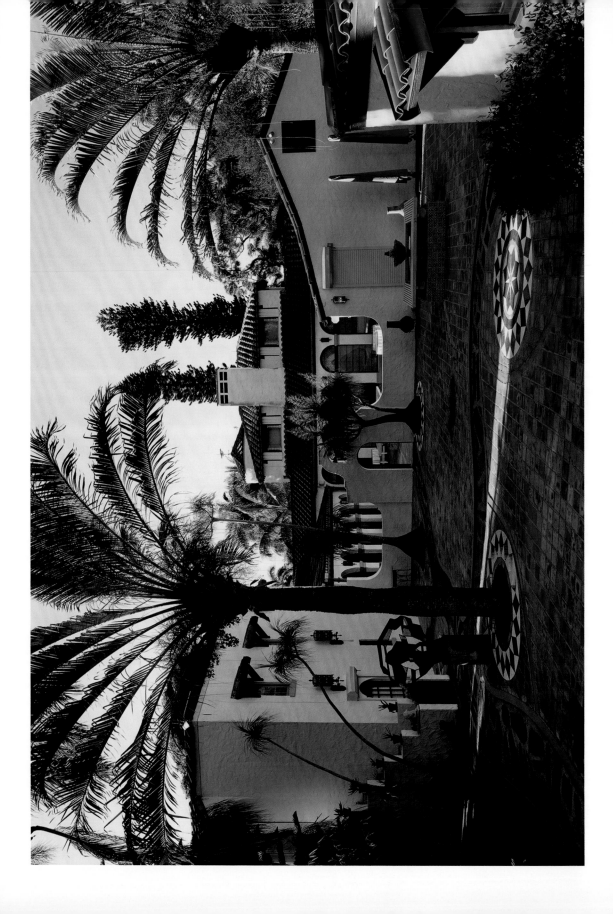

years, until Eric's death in 1940. Ada Wilhelmina then sold the winter retreat to George W. and Maria Thompson. Prominent citizens in Fort Myers, the Thompsons credited their financial success to George's involvement in the nationwide communications industry. He also owned the local Inter-County Telephone and Telegraph Company.

Significant changes occurred during the Thompsons' years in the home. Alterations included moving walls in the wings and repurposing rooms, as well as enclosing several courtyard doors and windows. Wall coverings and flooring, among other cosmetic items, were also updated during the Thompson years.

Maria, who was reclusive in her later years, also remodeled the master wing. Personalizing the multipurpose room allowed her to spend much of her time there in solitude. The addition of iron grates over the windows satisfied her desire for privacy and security. Though the Thompsons took great care during their tenure, the lavish estate seemingly lost some of its luster. The Thompsons enjoyed the estate together until George's death in 1967. Maria remained until her death in 1981.

Having learned of the old estate on Wales Drive that was for sale, John and Fran Fenning were curious. After a tour of the house the two climbed the gracious stairs

to the pool gazebo and, when looking back to the house, John casually asked Fran, "Do you want it?," she simply replied, "Yes," and the Jewett gem embarked on an exciting new beginning.

Dr. Fenning, a world-renowned orthopedic surgeon who pioneered innovative joint replacement surgical procedures, and Fran, a longtime antiques dealer and collector, proved a perfect fit for the grand property. The Fennings began years of loving work on the estate, which included a near restoration to original conditions.

The contemporary carpeting was removed, revealing the original floors, and wall coverings were stripped to the original plaster. Later, walls in the wings were removed. Recovery of the original floor plan, including the accidental discovery of a second bathroom in the east wing removed by the Thompsons, was implemented. Windows and doors once enclosed were opened, and the security bars removed. The entire property benefited from a thorough maintenance regime and a respect for its history.

Additions to the estate include the elaborate octagonal wine cellar attached to the existing "playhouse," as well as a modest expansion of the existing kitchen and an adjacent catering kitchen. The results show both old and new blending in the spaces. Original detailing, arched

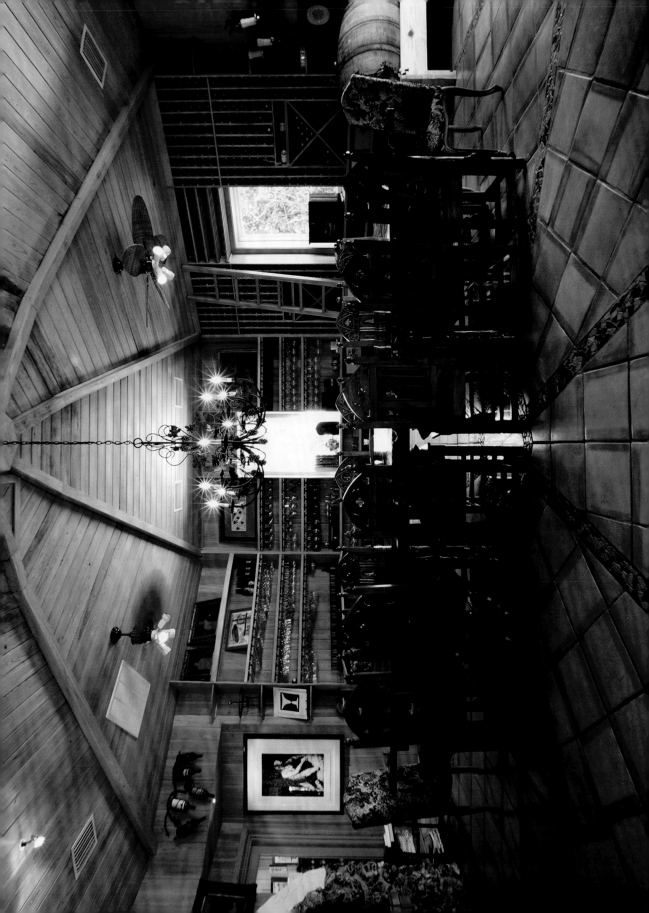

doorways, built-ins, and wall finishes combine with custom cabinetry and industrial appliances. All proved desirable to meet the Fennings' lifestyle.

With much of the work accomplished, the Fennings decided it was time to honor the past. John and Fran underwent the rigorous process and were subsequently awarded the prestigious listing of their home on the National Register of Historic Places, which was recognized as the Jewett-Thompson Estate.

Fran's love of antiques and the couple's collective passion for the arts guided them in completing their riverfront home. Walking through the home today one feels a dazzling thrill created by the architecture, art, and collectibles. Furnishings—largely antique and as detailed as the house itself—create an elegance that anchors each room. Walls are covered with a decades-long love of accumulating prized art, ranging from classical to contemporary. Many pieces are periodically shared on loan to galleries and museums.

As longtime collectors, and later a close personal friend of artist Robert Rauschenberg, the Fennings amassed one of the largest private collections of Rauschenberg's works in existence. Rauschenberg, widely considered one of the leading artists of the last half of the twentieth century,

created a home and studio on Captiva Island in the 1960s. He was a visible and integral part of the Southwest Florida art scene for decades.

Beyond their personal collections, both John and Fran have long supported arts within the community through their time and financial contributions. Arts for Act, the Naples Philharmonic, the Sidney and Berne Davis Art Center, the Florida Repertory Theatre, the Fort Myers Community Concerts, and the Southwest Florida Symphony are a handful of many arts and cultural organizations benefiting from this interest.

Their giving is not restricted to the arts. John's passion as a physician for making people well also guided the two in their community giving. Most notable was John's role in establishing We Care for Lee County, a nonprofit that provides free medical care to those in need.

With the couple's passion for causes, the grand estate has hosted countless galas, receptions, and fundraisers to benefit these organizations. The home has come full circle under the Fennings' ownership from the early days of Eric and Ada Wilhelmina Jewett.

When asked if she and John ever thought about an eventual downsizing, Fran replies without hesitation, "Never." During the writing of this book, sadly, Dr. John

OPPOSITE:
The wine cellar tasting room.
Photograph courtesy of Andrew West.

The exterior courtyard is a perfect space for entertaining. Photograph courtesy of Andrew West.

Fenning passed. Although John is no longer a physical presence in the home, it is far from a quiet retreat. Fran continues as she always has, enjoying antiques and collectibles, as well as supporting and staying involved in the arts. Importantly, having grandchildren across the street keeps a constant patter of laughter and fun enlivening the home.

Fran shared during a conversation that over the years numerous magazines and publishers requesting to profile their home, including *Grandeur, Home & Garden,* and *Architectural Digest,* have approached them. The authors of this book are tremendously honored that John and Fran decided prior to his passing that this project would be the first time they would open their home to publication.

2

Endearing and Enduring

12

The Gift

1121 Wales Drive

THIS 1940S COLONIAL REVIVAL home provides a nostalgic example of a style not commonly seen in the City of Palms. The square form and shallow hipped roof, symmetrical two-story facade, and central front entry with modest entry porch follow the World War II period's restrictive trends.

The simple formality of the exterior continues in the interior, with a typical design comprised of three to four rectangular rooms with a central staircase. Although this home has a simple floor plan, it contains over 2,500 square feet of living area, which was substantial for that time.

Though lacking the often-elaborate details surrounding windows and doors seen on homes of this style, the home remains elegant, with its graceful copper porch roof and delicate slender columns. The recessed, solid-paneled front door is absent the more traditional details of sidelights, fanlight, or decorative pediment and pilasters. However, it complements the home's overall aesthetic and proportions. Symmetrically placed double-hung windows, balanced in scale to the home, create interesting design elements in the facade.

A shutter-style door evokes a casual welcome. Photograph courtesy of Andrew West.

Shutters flanking the windows add an element of ornamentation, and also perform a utilitarian function. The area being prone to hurricanes and strong summer winds from the adjacent Caloosahatchee River, the shutters are intended to serve as both protection from windstorms and an aesthetic feature.

Set back from the main structure is a Colonial Revival–style hipped-roof garage with later rear additions. Connected by a breezeway to the main structure, this feature adds to the overall form from the street view.

The tale of the home's sole owners for over seventy years is extraordinary. Sidney and Bernese Davis' contributions to Fort Myers have had decades-long effects on the Southwest Florida experience. The story of how their home came to be is better known than the house itself.

Sidney, a native Virginian, risk taker, and budding entrepreneur, had heard of the wealth being created in Florida real estate in the 1920s and wanted to be a part of it. In 1925 he bought property in Tampa sight unseen and, while on a visit to see his purchase, coincidentally met Colonel J. W. Blanding, president of the Lee County Bank, Title, and Trust Company. Small talk started, and when Sidney shared his banking experience, the colonel was so impressed with the young man that he offered Sidney a

position. By the end of the conversation, Sidney had accepted and telegrammed his resignation to Virginia.

After several years with the bank, and the Florida land boom now well over, Sidney had a desire to pursue business on his own. He left the bank in 1933 and opened the Sidney Davis Men's Store in 1934. Later to become known as the premiere men's store in the area, it was a rite of passage for young men growing up to get their first suit from Mr. Davis. While growing his business, Sidney began courting Bernese Barfield, and in 1939—the same year Berne was crowned "Queen of Edisonia" at the annual Edison Festival and Pageant of Light—the two were wed.

Despite being busy with growing his business interests and courting his future wife, Sidney had also become fully engaged as a community leader and a friend to many. Among these friends were Eric and Ada Wilhelmina Jewett. Eric, an Australian actor, and Ada Wilhelmina, a New York heiress and socialite, had built what is arguably one of the grandest estates in Southwest Florida in the mid-1920s along the Caloosahatchee (see chapter 11, "Dramatic Queen"). Although they were only in Fort Myers on vacations throughout the year, they had a special fondness for Sidney and his future bride. To celebrate their pending

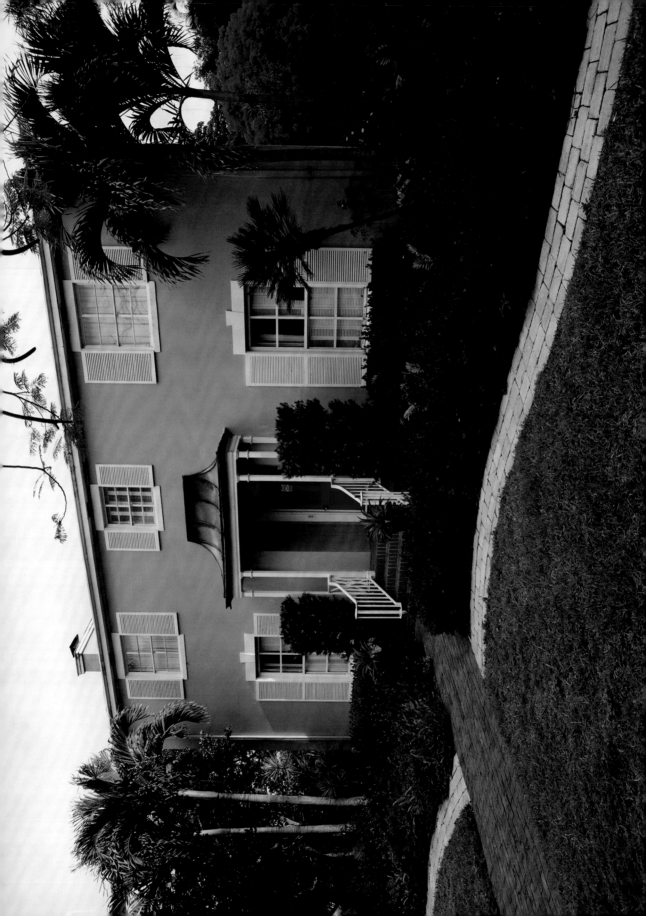

marriage, the Jewetts carved out a corner portion of their riverfront estate as a wedding gift for the young couple to build a home. Rumored is that following completion of the home, the Jewetts paid off the bank note Sidney had borrowed to build the house.

Whether or not the generosity of the Jewetts influenced the way in which Sidney and Berne led their lives is untold, however, both committed their lives to Fort Myers, working tirelessly to better the community. The list of organizations in which they have been involved, the nonprofits supported, causes championed,

and friendships made is impressive, and seemingly unbelievable.

Since Sidney's death in 1989, Berne continued to rally for her community. Passing in March of 2016, at the age of 102, she had become better known for her philanthropic contributions than for her hands-on efforts. Most today do not realize the full impact the Davises have had on Fort Myers life. The names atop the stately 1930s Neo-classical former Whitehurst Federal Building in historic downtown that so prominently reads Sidney and Berne Davis Art Center will surely pique curiosity.

13

Colonial Dame

3432 West Riverside Drive

A CLASSIC COLONIAL REVIVAL sits tucked along meandering West Riverside Drive. Among tropical foliage, the northern-style-inspired home adds a rare charm to the river-front neighborhood. The semicircular driveway, lot orientation, modest landscape, and mature canopy coverage add to a sense of a country house in an urban surround.

Built in the 1930s, this side-gabled house illustrates a period of design simplification. The symmetrical shape has a central section containing the front entry. Formality is solidified by a triangular pediment and supporting pilasters surrounding the door, flanked by mirrored bay windows on the first floor. Similarly placed windows above and matching chimneys situated on the gable ends further illustrate the style. Two side wings, although significantly different in size, are similar in form and offer additional balanced components. Typical clapboard wood siding, shutters, and minimally detailed elements provide a glimpse of the home's Colonial roots.

OPPOSITE: *Classic Colonial on the Caloosahatchee. Photograph courtesy of Andrew West.*

14

Diminutive Deco

1845 Monte Vista Street

FLORIDA'S EAST COAST City of Miami's South Beach is famously known for its cache of Art Deco commercial and residential buildings. Popular from the 1920s through the '40s, the style combined homages to the antiquities of Egypt and the products of Machine Age technology.

This small 1937 house in Fort Myers is a prime example of the Art Deco that appeared on the southwest coast. Concrete-block construction easily creates a rectangular massing with a flat roof and a smooth stucco finish. The exterior provides a simplistic base to exhibit integral elements. Significant features include banding along rooflines as well as the more apparent vertical and horizontal lines gracing the facade; a corner glass block portal window; recessed entry flanked by fluted curved walls; broad low-rise planters; and scuppers dotting exterior walls.

Though the bold, bright paint colors often associated with the Art Deco style are not the current exterior palette, the choice to use black and white highlights the fundamental contrast and showcases the geometric designs. The result brings an inspiring encounter with an iconic style.

OPPOSITE: *Classic Art Deco styling remains contemporary. Photograph courtesy of Andrew West.*

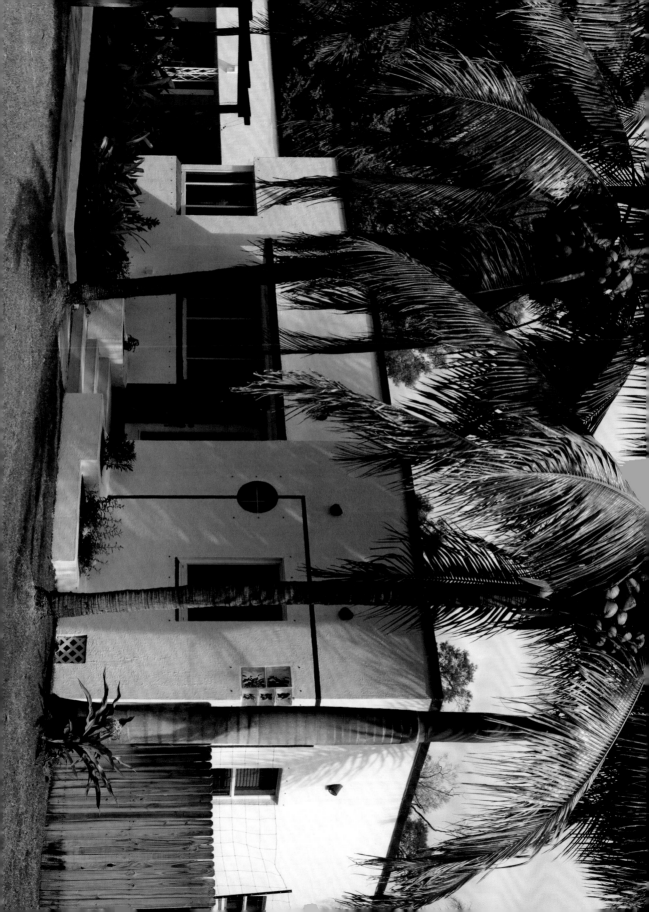

15

Southern Charmer

1307 Alcazar Avenue

FAMILY ROOTS RUN DEEP in the South for Clay and Jeana Crevasse. His family landed in Northern Florida in the 1830s, and her family's history began around the same period in Southern Mississippi and Northern Florida. As the couple was toying with the idea of leaving Pensacola, Florida, Clay spotted a position available with the Smoot Adams Law Firm located in Fort Myers. Although they had not considered moving to Southwest Florida, the job led to an unexpected new life.

Fort Myers did not shout "southern city" to the Crevasses. Most notably absent for Jeana were the ornate churches and grand architecture of the "Old South" that she had been raised with and loved. Although Clay had no interest in architecture, he did not see the historical environment he had been accustomed to. Nonetheless, there was a sense of community, a good career opportunity, and a desire to make a move before Jeana gave birth to their first child. They opted to make the City of Palms their new home.

Initially settling into a home on Shaddelee Lane, Clay and Jeana, along with their newborn, warmed to life in Fort Myers and welcomed a second child to the family two years later. After they had been established in the community for a decade, with two young children

becoming active, the pair felt the time had come to find a larger home. A more central location was important to meet the demands of the family's lifestyle. Clay and Jeana's search was complete when they found an eclectic Colonial Revival situated across from the Caloosahatchee River within the Valencia Terrace neighborhood.

As the 1930s progressed, the formality of the traditional Colonial Revival was often minimized to accommodate a changing society and functional needs, such as the addition of garages. To reduce construction time and costs, ornate detailing was eliminated or reduced. Variations based on the owner's selections were often incorporated, adding to the eclectic design.

The basic square form of this house, constructed in 1939, was slightly modified, with a recessed, or stepped, front along one-half of the street facade. This area features a gracious entry with the original raised panel door, sidelights, and an ornate fanlight. The cantilevered balcony above provides protection from the summer rains. Balancing the facade is a large bay window, with an additional centered window above, allowing ample light into the formal dining room. A side sunporch completes the original home.

Nearly two thousand square feet, the interior space

A peek through the garden entry. Photograph courtesy of Andrew West.

features basic paneled doors, detailed yet not overly large moldings and accent trim, built-in furnishings designed for function as much as aesthetics, and an open staircase.

Later expansions include an enlarged kitchen area, a new family room, and a master bedroom. Guesthouse and garage additions have created nearly 3,500 square feet of livable space today. This work expanded the corner parcel to a total of three and one-half lots.

While the size, location, and style were ideal for Clay and Jeana, the home itself was not. The pair set out to accomplish much of the work typically needed by an older home, adding along the way a little southern charm! Substantial upgrades, including new HVAC, plumbing, and electrical systems, as well as renovations to the added kitchen, family room, and master bath, have created contemporary-styled spaces.

Exterior work involved adding features to the front of the house. Jeana and her father installed the ornate iron railing on the second floor balcony, replacing a modestly styled railing. A decorative wall and fence, brick pavers, and formal fountain transformed the open lawn, creating a courtyard feel. The backyard received similar attention, with a decorative fence, enhanced landscape, an expanded pool area, and a large trellis. The outdoor living space has proven to be integral to the tropical lifestyle the Crevasses discovered in South Florida.

After living in this home for nearly fifteen years, Clay still finds one of his favorite features of the house to be the fourteen-inch-thick plastered walls that remind him of the quality and style of the 1930s. Before her passing, Jeana shared that she loved the centered fireplace in the formal living room as much in recent years as when she first entered the house. Their affection for, care of, and influence on the home are evident throughout.

16

Welcome to the Ranch

1720 Marlyn Road

THE FUTURE OF RESIDENTIAL construction was foreshadowed in this 1940 ranch-style home nestled within the elite Edison Park neighborhood. It is an area that began its first recognizable development during the Florida land boom, when a young entrepreneurial developer sold the promise of amenities not always seen. Included were curvilinear streets, decorative street lighting, sidewalks and curbs, and landscaping, as well as the prominence of living in a neighborhood named after the well-known inventor and winter resident, Thomas Edison.

The collapse of the Florida real estate market, followed by the Great Depression, halted construction along the streets of Edison Park. The result was a neighborhood spotted with stately houses interspersed with empty lots available for sale at a fraction of the price once commanded.

As the years passed, lots were slowly purchased and homes with trending designs were built. Today a designated historic district in the City of Palms, this still-desired neighborhood represents the transformation of Florida development over the years. With homes reflecting every decade from the 1920s boom era to the 2000s, Edison Park has remained fluid in growth while retaining the individuality first envisioned.

OPPOSITE: *The single-story cookie cutter takes shape. Photograph courtesy of Andrew West.*

Already embracing the modernization that would come from the war and the abandonment of lavish high-style design, homes of this period were built largely for function and efficiency. They also began to follow the trend of streamlining while taking advantage of low land prices. Unlike the often multistoried homes built with great detail and ornamentation on smaller parcels of land, this period saw the rise of single-story homes with broad street frontages on large lots and minimal unnecessary detail or design. Luckily, although this trend affected Edison Park, its early prominence encouraged even the most minimally styled homes to have some degree of design, as seen in this house.

One of only a handful of homes constructed during the war period in the neighborhood, this structure's design and influence hint at what was to come. The home was built by members of the prominent Grace family, who had a long history of both medical and law practice in the community. The rooms, including three bedrooms, two bathrooms, a kitchen, a living room, and a dining area, were spacious and laid out for ease of circulation. High ceilings and large windows enhanced the feeling of spaciousness. A den or library was included in the original floor plan, as was a carport designed within the primary roof structure abutting the front entry.

A modest U-shaped floor plan and low-pitched hipped roof and windows create interest in the structural features while emphasizing the low, spreading design of the ranch house. Original wood siding also reinforces the horizontal nature. As with most ranch homes, sweeping overhangs and elaborate trim detail are absent. Traditional elements include six-over-six wood windows and the federal-style front entry surround that reflect both personal style and a desire for aesthetic appeal.

The first significant alteration occurred in the early years when the original carport was enclosed, creating a fourth bedroom and third bathroom, while a garage at the rear was constructed. In the 1960s a previously added carport at the rear was enclosed and opened to the house as a spacious family room, bringing the total size of the home to more than 2,400 square feet. A kitchen renovation occurred in later years. The house remained in the Grace family until the 1990s, a decade that was to bring four separate owners by 1996, when it was purchased by Omar Rieche.

Omar was drawn to the character and casual elegance, having previously owned two historic homes in the Tampa Bay, Florida, area. From the hardwood floors, moldings, and tile work to the original glass doorknobs, Omar could

OPPOSITE, TOP: *A built-in bookcase provides a functional backdrop to the cozy den. Photograph courtesy of Andrew West.*

OPPOSITE, BELOW: *The grand piano nestled in a nook. Photograph courtesy of Andrew West.*

envision this as his home for many years to come. Additional selling points were the eclectic Edison Park surroundings, the varying home styles of the neighborhood, and the diversity of neighbors, as well as the proximity to historic downtown Fort Myers.

Since taking ownership, Omar has made modest alterations to the interior. The results are a reflection not only of his personal style but of the way in which he and partner, Len, live. Antiques, Mid-Century Modern, and more contemporary furnishings; brilliant wall and trim color selections; and inspiring artwork blend to inspire both excitement and comfort. Noticeable changes, including additional moldings, the replacement of select windows, and the addition of new French doors, enhance what is within the home rather than define it.

The most significant changes since Omar's purchase have been on the outside. Extensive effort, planning, and maintenance have created a picturesque landscape and a series of outdoor living spaces that few homes could rival. A formalized front lawn with a mix of landscaping materials, colors, and textures create a parklike setting while accenting the home. In the back, a detached garage that had been constructed after the rear carport was enclosed in the 1960s was demolished to make way for a resort-style

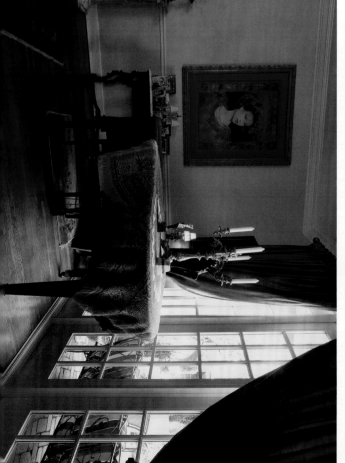

pool, tropically lush landscape, and casual entertaining spaces. A new garage was constructed at the far corner of the property. Its situation on the lot and design cohesion with the house and the surrounding landscape allow it to naturally blend in as if it has always existed.

Though having undergone many alterations, this home has retained many of the original elements—and all within the overall modified ranch floor plan as first designed. It is a fine example of how a well-built home adapts to the long-term changes of its occupants.

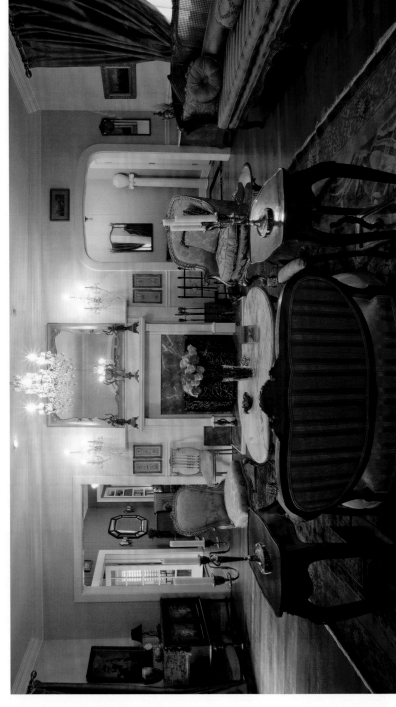

RIGHT: *Antiques unexpectedly fit in the postwar Ranch. Photograph courtesy of Andrew West.*

OPPOSITE: *The tropical features add new character to the old ranch. Photograph courtesy of Andrew West.*

17

Suburban Deco

1276 Osceola Drive

BUILT IN 1940, this house combines in its original floor plan the traditional Colonial Revival layout with modest Art Deco influences in its exterior styling. The home lacks significant detailing and instead appears more "streamlined," as the period of American innovation was under way. Deco-influenced detailing includes the curved portico, the circular side wing, and the use of glass block. The shallow pitched hip roof allows the vertical form of the house to take prominence, and later additions remain set back from the front facade.

The well-manicured lawn and landscape and the appropriately designed additions complement the original rectangular home well.

Art Deco styling with a traditional floorplan. Photograph courtesy of Andrew West.

Contemporary elements update this 1940s ranch. Photograph courtesy of Andrew West.

18

Rambling Ranch

1326 Gasparilla Drive

THE CURRENT OWNERS chose this home upon relocating from western Massachusetts in 2012. From Lima, Peru, the Miranda-Sousas first experienced life in the United States in Tampa, Florida, where Alejandro completed a residency in urology before relocating "up north." Familiar with Southwest Florida, and faced with an ideal career opportunity, the Miranda-Sousas moved to Fort Myers.

Barbara chuckled when she said that she had not been interested in looking to live anywhere beyond the McGregor corridor. Upon touring this home, she immediately knew it was for them. After a visit by Alejandro confirmed her thoughts, the couple made an offer a few hours later. They found the home to be exactly what they were hoping for in the City of Palms.

First built in 1950, the house was built in the popular Florida ranch style, with large windows and a broad, low-pitched shingle roof that emphasizes the horizontal design and low height. The house is finished in a combination of stucco and brick, a style common in South Florida.

Originally built with three bedrooms, the home has undergone multiple expansions and significant renovations to create a stylish residence. The size increase began with the addition of a family room, a two-car garage, and new driveways, which were mostly completed in the 1990s and 2000s. Recent work includes a pool that creates the feel of a private resort. The ideal family area, a single-story addition at the rear of the home, expands the square footage and usable space without conflicting with the overall design aesthetic of the ranch plan.

A second enlargement, the most significant and most visible, is a four-car garage with a master suite above. The rooflines mirror the hipped form of the main house, and introduce gabled dormers and a full-length eyebrow defining the first and second floors. The story goes that the garage addition, perhaps done by Richard Ledbetter, was designed to accommodate eight vehicles with lift systems to store his collection of automobiles safely without being visually imposing.

An equally impressive feature of this property is the lush semiformal landscape. Combining both a mature tree canopy and younger plant materials with a variety of hardscape materials, finishes, and lighting softens the juxtaposition of styles.

A simple side entry is now framed with an elaborate Federal-influenced surround. Photograph courtesy of Andrew West.

Unifying elements include decorative window lintels, nonfunctional shutters, fascia, soffits, and decorative rafters. Although these details create a mix of architectural influences and some nonfunctional aesthetics, together they result in a cohesive design.

Custom touches are evident throughout and add to the uniqueness of the original home: the irregular plan shape, the extended windows and wall projections, the modestly elevated front entry arrival, and the rear side-entry parking area that was once on the opposite side.

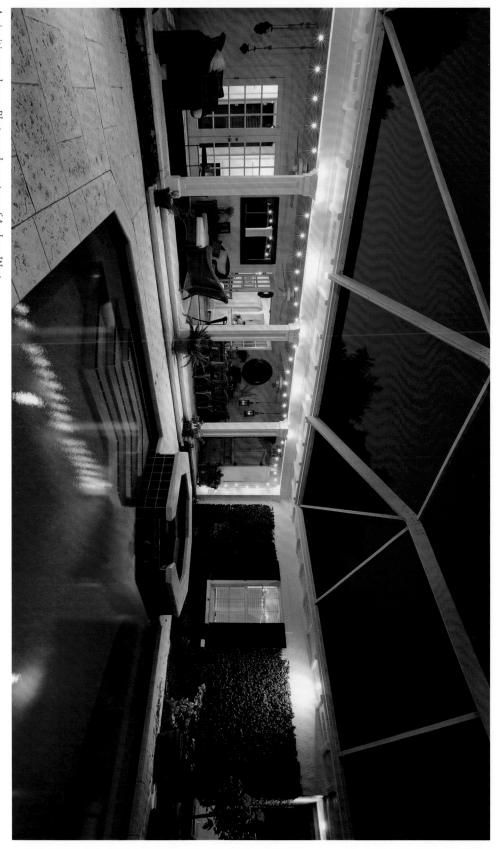

An inviting pool area. Photograph courtesy of Andrew West.

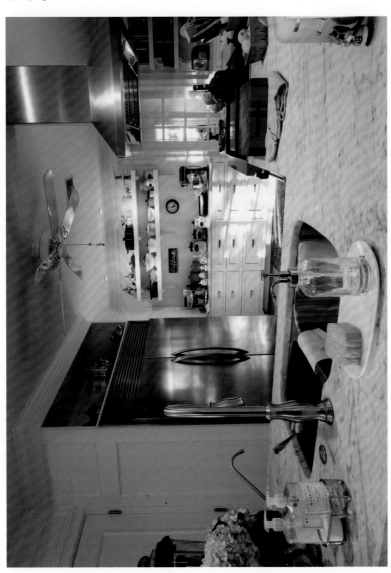

The hub of the house. Photograph courtesy of Andrew West.

The result is a spacious and highly detailed home. The more than 4,500 square feet consist of four bedrooms, four bathrooms, a formal living room, a kitchen, a dining room, a family room, an office, and workrooms. Custom design features, built-ins, trim moldings, and stylish furnishings offer comfort in airy and bright rooms. With primary living spaces created by a U-shape enclosing the pool and the lanai, there is a cohesive flow between distinct living areas. The home has grown over the decades into a place that has proven to be ideal for the Miranda-Sousa family.

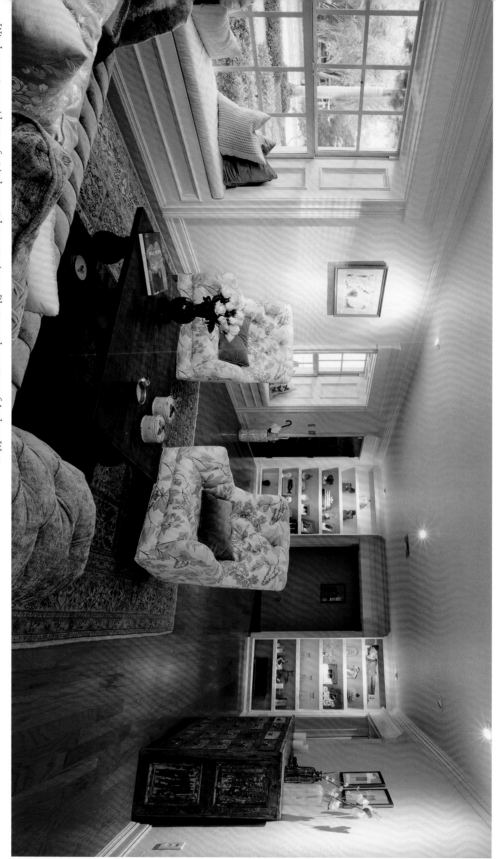

Window seats provide a perfect indoor-outdoor experience. Photograph courtesy of Andrew West.

19

Sister Houses

1303 and 1309 Cordova Avenue

C. D. AND CHARLOTTE BEVER started the B&B Cash Grocery in Avon Park, Florida, in the 1920s. The original store expanded into the U-Save Supermarket chain. The corporation exists today as B&B Cash Grocery Stores, based in Tampa, with a Bever family member at the helm. The company operates U-Save as well as the Handy Food Convenience Store chain in the Tampa area.

The Bevers built a home in the Rio Vista neighborhood of Fort Myers in the 1940s. After the death of her husband in 1955, Charlotte bought two adjacent lots in Lynn's Addition of then Poinciana Park Subdivision. She convinced her friend Laura Roediger, also a widow, to move to Fort Myers. Situated near the Caloosahatchee River, these two small Mid-Century Modern houses were designed and assembled by local architect William "Bill" Frizzell and gained the reputation around Fort Myers of being the "sister" houses. In reality, they are the "friends" houses.

The Cordova houses were two of Bill's early works. Bill came to Fort Myers in 1955 and became a prolific and well-respected architect about town. Homes, churches, schools, and retail buildings have the Frizzell touch. Among the prized examples are Cypress Lake Middle

and High Schools, Fort Myers City Hall, Lee County Bank, and former Lee County Library. Frizzell built one of the largest architectural firms in Florida, with additional branch offices in Daytona, West Palm Beach, and Orlando. Bill died in an airplane crash near Daytona at the age of forty-nine.

These two homes sit side by side on Cordova Avenue. In nearly the same condition they were in when completed in 1957, they remain two of the strongest examples of Mid-Century Modern–style homes in the region. A drive-by will stun the viewer. The unique homes appear out of place but add curiosity to the neighborhood. So unique are the homes, the story goes, that neighborhood uproar was so strong the city refused to approve their

construction. It was only after Charlotte suggested to the local Coca-Cola distributor, who was very influential in city government, that if she wasn't able to have her new home as she designed in Fort Myers, perhaps she wouldn't be inclined to have her U-Save grocery stores carry Coca-Cola products. Shortly thereafter construction of these two homes was approved.

Modernist philosophy can be seen throughout these linear buildings. Structural elements, function, and purpose have been blended with the natural environment. Intended by design to respect nature, the materials are often finished in their natural state or left exposed. Large expanses of glass and clean lines allow the outdoors in without ornamentation obstructing its presence.

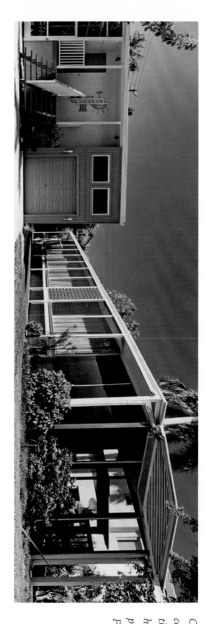

Controversy arose when construction began on these Mid-Century Modern houses. Photograph by permission of Joshua Colt Fisher.

Structural and architectural features are highlighted in their simplest form, creating interest as the two spaces merge.

The varied low, flat roofs create the uppermost plane of Mid-Century Modern design. This common feature is especially clear on the Bever home at 1309 Cordova. Front entries are often obscured, as is also apparent, to create a sense of privacy. Both of these homes include the characteristic open floor plan, large windows, and sliding doors. The screen enclosures are included for various reasons: to increase the sense of privacy, to allow outdoor living, to draw in the cooling river breezes, and to keep pesky insects out.

Also in keeping with the style, the use of multiple materials and their placement is common in both homes. Concrete block, horizontal and vertical wood siding, stucco, and terra cotta brick screening are the primary materials. The screens and block are in a natural finish, while the wood and stucco color selections extracted from nature add contrast and draw attention to the varying finish elements.

The elevated construction lends a somewhat modular appearance to the overall form. This also serves a practical purpose. The elevated floor level allows for air circulation below the structures, keeping them cooler and drier in the heat of summer, and minimizing the risk of flooding and invasion by various critters.

The Bever family continues to use Charlotte's home as a vacation spot. Upon Charlotte's death in the early 1970s, the house transferred to her two sons, C. C. and Andrew. C. C. became the sole owner in 1993. The home retains most of its original components, including the lighting fixtures, replicated draperies ordered through J.C. Penney (where the original sets were purchased), a Thermador range and refrigerator, pegboard cabinetry, and even the saucers, cups, and cutlery.

Laura Roediger's home at 1303 Cordova took a different path, after only one other owner, Debra Stone Ferrari, who had the home for fifteen years. The two-bedroom, two-bathroom residence was perfect for Debra, and was later shared with her husband, James. Debra's collection of Mid-Century Modern furniture, especially those pieces of Danish origin, fit the home to a tee.

Debra and James remodeled much of the home.

They proudly restored the historic features that could be salvaged. Their work includes rewiring, replumbing, replacing the kitchen, remodeling one bathroom (but the other remains original), replacing the tongue-and-groove

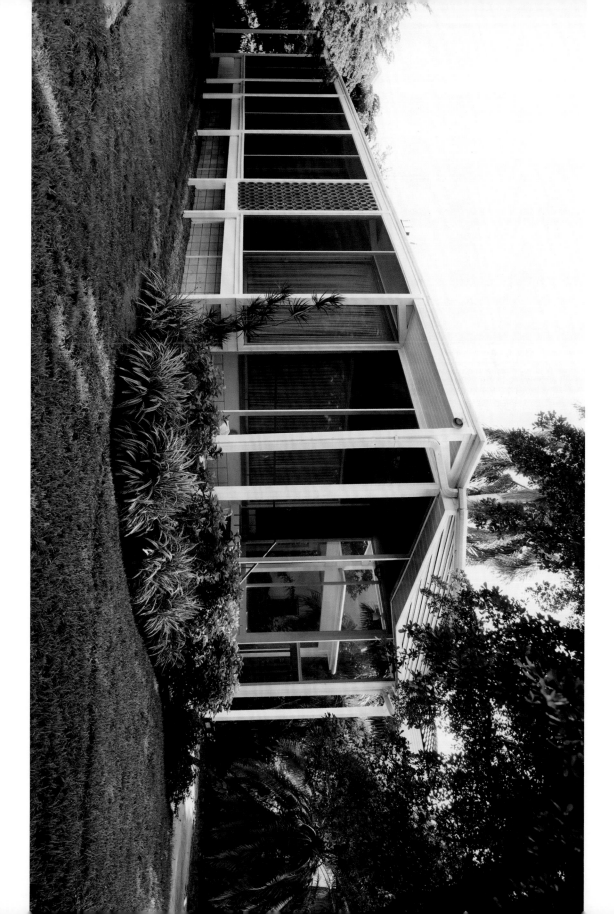

wood flooring, replacing the roof, and changing the music room, which initially had a wall-unit drop-down record player, into a sitting room.

The couple installed a new air conditioning unit and handler underneath the house, as well as a propane tank initially used for heat. There is a small basement, which serves as important storage space in the small house. Debra enclosed the carport for her art studio, an action that is easily reversed.

Debra and James enjoyed walking, biking, and visiting with neighbors until they sold the home to begin a new life in Colorado in 2013. Now they love to share stories and memories of their time spent in the Frizzell masterpiece.

Today, more than sixty years after they were built, these "friend" residences endure as fantastic examples from the evolution of the Sarasota School and the young Bill Frizzell. They sit together, alone in the Mid-Century Modern style, among the traditional neighborhood that fought their existence many years ago.

OPPOSITE: *Half a century later, the Mid-Century style still provokes curiosity in the neighborhood. Photograph courtesy of Andrew West.*

Exterior building elements were thoughtfully considered for the interior effects, as shown in the uniquely sunlit office. Photograph by permission of Joshua Colt Fisher.

Family Retreat

1306 Shadow Lane

THIS SHADOW LANE HOUSE is located in what was once an orange grove planted by Dr. Franklin Miles, who founded the Dr. Miles Medical Company in 1887 to research improvements in diagnosis and medicinal treatments. Dr. Miles spent the 1904–5 winter in Fort Myers and soon bought a home on downtown's First Street. He then purchased several thousand acres to the south, toward the coastal islands. Determined to succeed at farming as an additional career, he applied his research, development, and implementation skills to the agricultural production of the coastal sandy soil.

After many decades, the orange trees began to die off, and the area became the Country Club Estates subdivision. Sidewalks were not placed along the street as the development emerged—a decision made to protect the abundant long-established oak trees that continue to make Shadow Lane a picturesque drive.

These oak trees drew Mina Corbin to select the location for a home with her husband, Oscar. The couple first came to Fort Myers in 1942 as newlyweds as the United States entered World War II. Mr. Corbin was stationed at the Buckingham Army Air Base. Mina became a secretary for Ewing "Unk" Starnes with Henderson, Franklin, Starnes & Holt, which remains one of the premier law firms in Southwest Florida.

While Mina lived on the base east of Fort Myers, her position brought her into town regularly and allowed her to become familiar with the people and the businesses and establish friendships and personal connections.

Following the war, the couple returned to their native Kentucky. After five years their desire to leave the "slop and the slush" of northern winters, along with the many "wonderful memories" of Fort Myers, enticed the Corbins to return to the City of Palms.

Having owned a Purina farm store in his hometown, Oscar took advantage of an impromptu discussion with a local feed store salesman while visiting Fort Myers. By the end of the day, he had made arrangements to purchase the business. Later Oscar expanded his business by opening a feed store in Naples, followed by a retail center in Central Fort Myers, and, eventually, the Colonial Garden Center.

Oscar and Mina initially rented a carriage house on Osceola Drive and enjoyed the McGregor neighborhood. Evenings were enlivened by parties in the park area, with lights ablaze and music by Arthur McKinley. With growing children and the need for more space, the couple wanted to build their own home.

Selecting an architect to design their home was easy, as the Corbins had become friends with Bill and Margaret Frizzell. As admirers of Bill's work, they chose him to design their home, although neither Oscar nor Mina had a strong preference for any specific style. Mina shares that Bill had originally designed this house for a different lot. The size fit the Corbins' needs, and the price was right. Construction began after some minor personalized adjustments and flipping the original floor plan to better sit within the existing trees. Little did the Corbins realize their home would be a model of Southwest Florida Mid-Century Modern and the architecture of Frizzell.

Built in 1956, the home is nearly identical to when it was first completed. The strong horizontal shape is accentuated by the carport roofline and covered walkways, and by their ties to the fascia and roof structure. Unadorned columns add vertical contrast while creating a screening effect. The separation between the carport roof and the covered walkways allows light to flood through the roof structure and highlight a landscape bed below.

The low-pitched, cross-gabled roof on the main structure is largely not noticeable except on the front-gabled western section. While most of the home is finished in wood, this projection is constructed with buff brick and includes ornamental louvers within the gabled roofline, adding contrast

The copper hood fireplace signals modern style and defines the living room space. Photograph courtesy of Andrew West.

The evolution of an open floor plan is apparent in this 1950s modern house. Photograph courtesy of Andrew West.

and texture to the front. The minimal ornamentation is in keeping with the Mid-Century theme. The surface planes of the facade, the materials, and the effect of light and shadow, as well as the overall form, add interest.

Characteristic floor-to-ceiling jalousie windows are used as much as possible, most noticeably at the rear of the home, to allow both light and breezes to enter, with large overhangs blocking direct light and rainfall. Although Bill conceived the overall design, Oscar and Mina appreciated how he accepted their input, particularly when specifying the finer details, including the doorknobs, fixtures, and push-button light switches. Mina's favorite components are still the pickled cypress walls, the vaulted ceiling, the clerestory windows, and the openness of the living room and family room.

Though the Corbins appreciated and enjoyed the original home for many years, they eventually made changes: the kitchen was enlarged and later updated, the family room was expanded, the large back porch was enclosed and added onto, and the larger screen porch off the living area was enclosed as well. An air-conditioning system was a welcome addition, and, although it was not included in the original construction, Bill foresaw that air-conditioning would become the norm and insisted on including metal ductwork and a closet to contain a unit. The layout and the features were ideal for both the family's daily life and the Corbins' entertaining needs.

The neighborhood proved the perfect fit for the Corbin family. Their sons and their daughter Ginny rode their bikes, played baseball, and easily made neighborhood friends. Ginny liked it so much that in 1986 she and her husband, Randy, bought the house next door. When asked how she felt about having her daughter and son-in-law so close, Mina chuckles, remembering her friends sympathizing that she and Oscar would soon lose their privacy and peaceful time as once again children would be climbing the trees and running through her house. Instead, Mina saw it as a treasure that her daughter enjoyed growing up in this neighborhood so much and that their family bond was so strong that Ginny would want to live with her husband and raise their children on Shadow Lane.

The City of Fort Myers itself became more to the Corbins than they could have imagined when first arriving in 1942. Oscar and Mina became deeply rooted and active in the community. Well known and respected, Oscar was "talked into" running for mayor in 1967 after a special election was held. He then formally ran and won in the 1968 and 1972 elections. He continued to lead

the city until he retired from politics in 1976, and then entered real estate development and sales.

Things changed significantly in Fort Myers during Oscar's tenure as mayor. Known as a progressive, Oscar was significantly challenged by a shift that was under way at the city's core. The Edison Mall had been built only a few miles south of the downtown in 1963. It was the first air-conditioned indoor shopping center in the United States, with three national competing retailers as "anchor" stores. As in so many other cities, Sears and J.C. Penney had once graced First Street for decades but now called the "mall" home. Oscar went on and asked businesses to move downtown and is credited with "saving" the historic city center while undertaking the first comprehensive revitalization effort since the development land boom of the 1920s. He championed needs beyond downtown as well, everything from improving the city's bond rating and investing heavily in infrastructure improvements to enhance investment appeal and future growth to tackling more delicate and controversial community issues such as supporting desegregation.

Now decades in place, Oscar's influence is still readily visible. This includes the Fort Myers City Hall, built in 1974 under his leadership, and, ironically, designed by good friend Bill Frizzell. The building was later dedicated as the Oscar M. Corbin Jr. City Hall in his honor. Oscar's legacy still resides in City Hall, as his son-in-law Randy began a long tenure as a Fort Myers politician decades after Oscar left, first as a two-term city councilman, and currently in his second term as mayor.

Though Oscar passed away in 2012, Mina says that he always called Fort Myers "paradise." He believed the city was a great place to do business and to raise children. In the home on Shadow Lane in which she has resided for over fifty years, Mina is grateful every day for the charmed life she has lived in the City of Palms.

21

Magic Matts

2903 Valencia Way

ROBERT MATTS WAS A LEADING ARCHITECT of the Mid-Century Modern movement in Southwest Florida. Having learned engineering and architecture "on the job" as a draftsman and designer in Cleveland, Ohio, he worked on projects designing chemical plants for companies such as DuPont and Goodyear.

By the early 1950s, Matts was ready to further his career. He relocated his family from New York to Fort Myers and took a position as a mechanical engineer with Bail-Horton. Matts's choice of Fort Myers was not random: firm principal George Bail was the son-in-law of a former employer in Cleveland.

Through practical training and working with local architect William Frizzell, Matts received his architectural license in 1956. He later opened his own firm, Robert H. Matts & Associates. His wife, Henrietta, joined him in the business as secretary-treasurer. He is well regarded today for his visionary designs.

Likely the most prominent example of his work is the First Harbour Tower condominium on West First Street in downtown Fort Myers. The multiresidential building is groundbreaking for both its strongly stylized design and for being the second condominium tower

project completed in Lee County. Matts and Henrietta called First Harbour home for the last decades of their lives. Among his legacy projects are the Christian Science Church, Bishop Verot Catholic High School, the Sanibel Causeway, and countless residences.

Matts designed his own home on Valencia Way using classic modernist principles. Situated on an oversized lot across from the Caloosahatchee River, the house sits rather unassumingly under a stately canopy. Both inside and out, Matts's original home today is just as it was when he completed it more than fifty years ago.

In this L-shaped residence, the smooth contemporary styling is enhanced by the use of natural building materials. The line of the flat roof on the single story house defines the form, appearing to "hold" it to the ground. Solid stucco banding directly below further emphasizes the broad plane. These elements aid in the horizontal and vertical contrast that dominates the exterior design.

From the front facade, attention is drawn to the original aluminum-frame corner windows, which illustrate this directional contrast while also defining the boundaries of the living space. Horizontally set cut stacked stone is used along the majority of the facade, as well as at a lower level, wrapping around to the more informal

A neighborhood park along the Caloosahatchee River is a treat. Photograph courtesy of Millie Dinkle.

northern side. The same stone also extends along the privacy wall, creating the illusion of a much larger home. The use of this stone emphasizes the height of the windows, particularly on the front section. Blending the natural stone with the sleek man-made aluminum is a characteristic of this style, and is used in similar fashion in nearly all of Matts's buildings.

Interestingly, this home seems to lack a prominently

placed front door. Anchored on one side with paired full-height windows and placed in the second tier of the home, the entry discreetly reminds us that formality did not guide the design concept.

The interior open floor plan includes a living room, a dining room, a kitchen, three bedrooms, an office, and two bathrooms. Minimal detail and use of natural elements such as stacked stone and wood features brings the outdoors inside. An interesting characteristic is that no two wall treatments or material finishes are alike. Perhaps Matts used his home to showcase his skill with various materials.

The minimal landscaping, with low-rise planters at the front-most projection of the home and modest perimeter plantings, emphasizes that the home was meant to be viewed and appreciated for its style rather than disguised by the surroundings. A lawn and the original pool dominate the rear section, within the L-shape. Expansive windows and sliding doors provide access, as well as allow plenty of light inside. The blending of interior and exterior is obvious.

Ironically, it was not Matts's talent, as illustrated in the style, that inspired the third and longtime home-owner Marjorie Whitehurst Berry Gilbert to purchase

OPPOSITE: Architect Robert Matts designed his family home. Photograph courtesy of Andrew West.

LEFT: The corner window is a signature of Mid-Century design. Photograph courtesy of Andrew West.

the house in 1973. Newly a single mother, Mrs. Gilbert had bought a riverfront lot several miles down McGregor Boulevard with the intention of building. However, when she considered the time it would take to build and the distance from downtown Fort Myers, then the anchor of life in Lee County, she began to search for an existing home. Finding this house in close proximity to downtown, in an established neighborhood she knew well (having grown up one block away), sold her on buying it and selling her riverfront lot.

Mrs. Gilbert says that move was intended to be a "temporary situation," as in fact she never liked the house. Her early plans to remain there until she found something more to her liking, presumably a Spanish-influence residence much like the home she grew up in, never came to fruition.

The comfortable flow and functionality of the house turned out to be exactly what she wanted. The quality of the neighborhood was important for her young children. Because she never intended to stay, Mrs. Gilbert jokes, she never changed the home in any way. From the original cabinetry and moldings to the varying wall finishes, it is a wonderful example of Matts's vision for his craft. Luckily, as the years passed and the children grew up, she developed a love for the home and an appreciation of the style and design that meant so much to Matts.

A realtor's "For Sale" sign recently became a new addition to this Mid-Century Modern house. After more than forty years, Mrs. Gilbert is ready for the next phase of her life. She hopes the future owners will develop the same love for the house she that she did while she lived there.

Original wood paneling and exposed stone are timeless in a Mid-Century. Photograph courtesy of Millie Dinkle.

Modern Dream

1370 Stadler Drive

THIS SMALL, UNASSUMING HOUSE symbolizes a band of brothers who came to Fort Myers to build their dreams of a better life. Detroit childhood pals Harold Lagg, Frank "Ace" Acetelli, and John Paul Jones served in the U. S. Navy during World War II. By 1953, the trio had created Michigan Homes in an endeavor to enter the postwar development craze. With connections in California, their initial land purchase was near Hollywood. That property became entangled in estate issues after the owner's death. A friend suggested Florida's Gulf Coast. The company based itself in Fort Myers in 1956 with the purchase of the Morse Shores subdivision, an area northeast of the city center.

Settling their families in Morse Shores, along with many Michigan Homes staffers, Lagg, Acetelli, and Jones then formed a team of designers, carpenters, and painters. Furnishings came from the popular Robb & Stucky furniture store, which was founded in Fort Myers in 1915. A model of the company's home type enriched the Morse Shores neighborhood until it, also being the office, moved to Fowler Street in 1974, where it still resides.

Floor-to-ceiling glass exemplifies new technology used in Mid-Century design. Photograph courtesy of Andrew West.

Thousands of Michigan Homes can be found throughout this region of Florida as far south as Naples and Marco Island, as far east as Labelle and Clewiston, and as far north as Punta Gorda. Additional subdivisions were created in Lee County, including one along Stadler Drive. The first Stadler homes were built in 1959 in a more developed urban locale and had immediate success. They drew attention to Michigan Homes and provided much-needed marketing for the more rural Morse Shores area.

Stadler Farms was a subdivision of Seminole Estates, which was surveyed and platted during the 1920s land boom. Like many neighborhoods, it was sparsely developed because of the bust, and the 1950s developers saved time and money with the ready-to-build lots.

Built in 1959, this Stadler Drive house is one of the early Michigan Homes. Though it has only two bedrooms and one bathroom, it exemplifies the

The owner's collection of Mid-Century furniture finds itself at home. Photograph courtesy of Joyce Owens.

Mid-Century Modern style. The original design is understood to be a collaborative effort among several of the company's architects. Lagg hired Paul Musler in 1964 as principal architect to create a more consistent representation.

Current owner Joyce Owens bought the home in 2004. Her parents' purchase of a condo on Sanibel Island in the 1970s brought her to the area as a child. After spending time in the United Kingdom as an adult, Joyce was more than ready to leave the gloomy country for sunshine and sand.

The proximity to her firm's downtown office played into the decision to choose this home. More importantly, as an architect and Mid-Century Modern enthusiast, Joyce was drawn to "perfect" contemporary design: large overhangs, good light, high sloping timber ceilings, and high clerestory windows. The glass entry is a favorite element. To pause in this space before being beckoned into the rest of the house has a fantastic effect.

Luckily for Joyce, none of the former owners made significant alterations. Her main task was to uncover the original skin and bones. She stripped off layers of rag-rolled and stenciled paint, a collection of flooring, and traditional paneled doors displaying various kinds of hardware. The results are smooth walls and an original poured terrazzo floor with a fresh polish that mimics the look of a lake. There is brickwork at the entry as well as on the fireplace surround. All elements are white, creating a simple, elegant jewel box.

Joyce designed an enlarged kitchen and master bedroom to increase the 1,300-square-foot home. However, she is reconsidering these changes after recently completing a backyard remodel. A spectacular mature oak tree that provides a centerpiece to a screened back porch, an outdoor dining area, a fire pit, pavers, and additional landscaping leave her wondering if she even needs the additional space. Taking a moment to consider her future in the home, Joyce comments, "Do I have to leave?"

The outdoor area expands the living space of the small home. Photograph courtesy of Joyce Owens.

3

Classic and Contemporary

23

Michigan Model

1625 Menlo Road

THIS TYPICAL THREE-BEDROOM, two-bath Michigan model home is nestled near the entry of the Edison Park Historic District. The subdivision, aptly named after the neighboring winter estate of Thomas Edison, contains a mix of old and new. It boasts the distinction of being the only residential historic district in Fort Myers containing homes built in every decade since its 1920s beginnings. In contrast to many of the surrounding homes on the street, this residence was likely accepted by the neighborhood when built in 1969.

In the 1970s, two prominent Fort Myers attorneys, John Woolsair and, later, Judge David Orosz, called it home. Well-known Fort Myers lawyer and native Frank Alderman III and his wife, Darilyn, purchased the home in 1980.

The Aldermans, who have deep roots in the Fort Myers area, are a branch of the pioneer Hendry family. Still highly regarded, the Hendry name is encountered repeatedly throughout Lee County and is the namesake of the adjacent Hendry County. The Alderman family was instrumental in the growth of the city. From the 1910s onward, they were deeply involved in business and development matters, from finance to new construction. The Fort Myers National Bank and the Fort Myers Country Club were two of their key projects. Today the Alderman Home on East First Street, designed by Addison Mizner for Frank Alderman Sr.

holds such significance that it is listed on the National Register of Historic Places.

This Menlo Road home began taking on the more contemporary look it has today during Frank and Darilyn's tenure. Darilyn led much of the design process to fit the lifestyle that she and Frank enjoyed. The result helps the home blend into the surroundings rather than stand out in the historic neighborhood.

The most significant work was completed in 1989 with the addition of a second story and the expansion of the

A South Florida welcome. Photograph courtesy of Andrew West.

ground floor. As with most ranch houses, the existing two-car garage dominated the front of the home. However, with the second-story addition at the rear and the replacement of the roof structure, the view of the garage is minimized. The side-gabled and steeply pitched aluminum V-crimp roof, in sharp contrast to the stucco finish, enhances the contemporary appearance Darilyn sought.

A minimalist entry courtyard was added and also finished in stucco. A detailed rough wood trellis provides privacy to the front while adding outdoor living space and interest from the street view.

A large pool and resort-influenced patio area was built

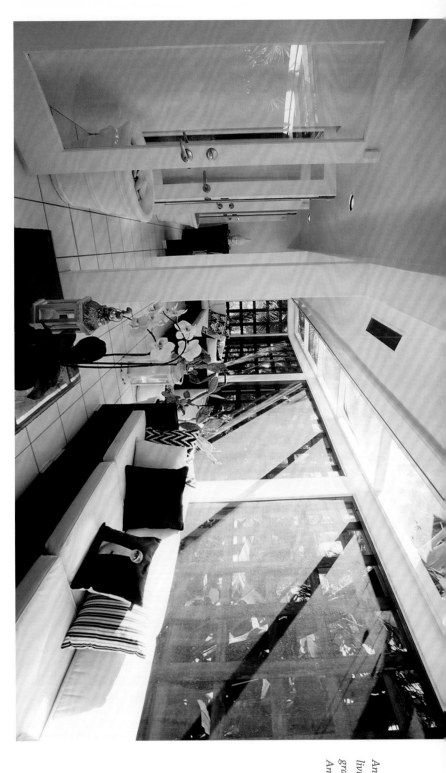

An expanded outdoor living space. Photograph courtesy of Andrew West.

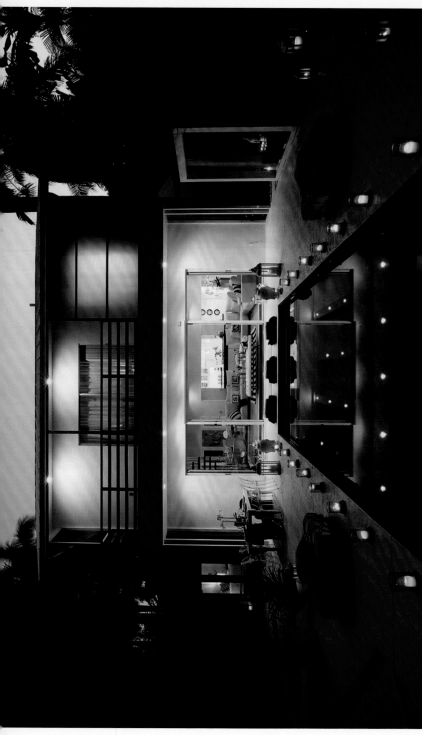

Nightlife.
Photograph courtesy
of Andrew West.

in 1991, complementing the already urban flair that began to be developed in previous renovations. The circular drive was added in 1996 as the last exterior alteration during the Aldermans' time in the home. Change came for Darilyn in 2010. Widowed, she decided to sell the house. The timing could not have been better for Sean

McGowan and Eric Smith. Exploring the area for a professional assignment for Sean, the couple was immediately drawn to the historic downtown, the numerous cultural attractions, and the uniqueness and small-town feel of the McGregor corridor. Both having lived around the United States and abroad, and with their work taking them around

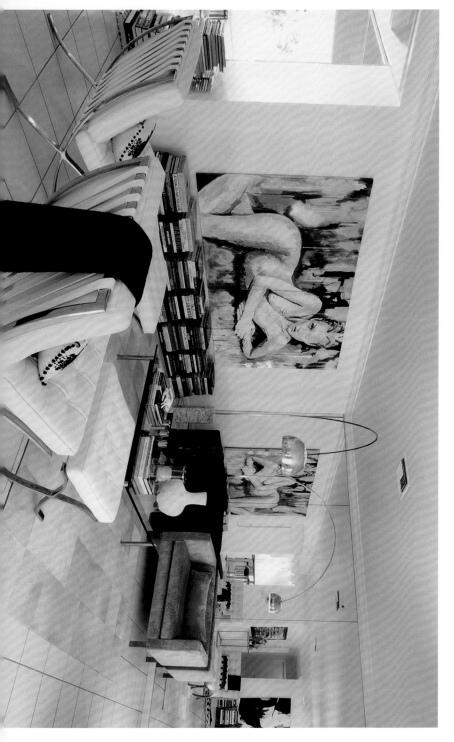

the globe, Sean and Eric thought Fort Myers might be the perfect change of pace from their lives and homes in New York City and Los Angeles. Immediately drawn to the urban feel Darilyn had created among the charm of old Fort Myers, the house was a sign of good times to come. Under Sean and Eric's ownership, the exterior has

remained relatively unaltered. Although the interior layout is mostly unchanged, it is the personal style of the couple that has created a spectacular home. Their style in furnishings, art, and decor, combined with the existing structure, evoke more of an urban and trendy Miami feel than one would anticipate in this 1960s ranch. Although

The owners' own art becomes the focal point of the formal living room. Photograph courtesy of Andrew West.

future renovations are envisioned, the home currently embodies all that the couple sought.

Their influence is evident from first approach to the entry courtyard, with its solid black double doors, stainless hardware, and the contemporary furnishings visible through the triple French doors to the formal living room. Inside, the combination of sophisticated styling and trendy design creates a feeling of tranquility yet excites one to see more. A nearly monotone color scheme in the walls, ceilings, and flooring blends with the contemporary furnishings of the same palette. Boldly vibrant accent pieces add the wow factor.

A formal dining room is complemented by a coffered ceiling. Past a dining set with acrylic and metal dining

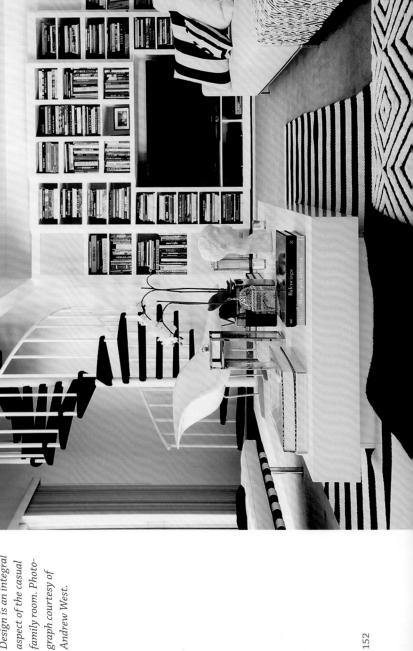

Design is an integral aspect of the casual family room. Photograph courtesy of Andrew West.

chairs is a sleek high-gloss white kitchen looking onto the oversize and dramatic great room, which appears to extend to the pool and patio through the full-length glass wall. A master suite, two additional bedrooms, and a bath complete the ground floor living space, all done in a calming decor.

The second story is composed of an expansive master suite. Following the direction of the ground floor, the rear exterior walls are largely glass. The room seems to be built within the tropical foliage and has a "tree house" feel. The Aldermans' original major renovation and second-floor addition included a master bath with glass doors off the shower space leading to the second-floor balcony with a privacy screen.

From an exterior view, the house itself becomes ancillary in a rare way. The second-floor balcony, various roof connections and angles, and the related structural elements resulting from various renovations disappear in the overall context. The focus is shifted to the experience within this small oasis among a historic neighborhood.

This once typical 1969 model ranch home has experienced a unique journey to become what it is today. Its story is filled with unique characters, creative vision, and an unexpected outcome.

An intimate outdoor space. Photograph courtesy of Andrew West.

24

Love by Design

1215 Caloosa Drive

HAVING MET AS TEENAGERS through youth groups sponsored by their respective synagogues, Carolyn and Bruce Gora first began married life in her hometown of Saint Petersburg, Florida. As a newly licensed architect, Bruce received a job offer that seemed to bode well for the duo's future. Carolyn, an art teacher, knew opportunity existed for her as well. Armed with an entrepreneurial spirit, love of art, and admiration of contemporary style, the Goras saw an opportunity to flourish in the diverse community they discovered in Fort Myers.

Drawn to the variety of homes and residents along the McGregor corridor, the couple made the first step toward building their "investment in Bruce's career," as Carolyn says, when an empty lot came on the market. The ideal parcel was surrounded by royal palms, as well as scattered with mango, avocado, and orange trees. Though the lot bore a hefty price, the newlyweds believed it, once part of an adjacent property, offered a rare opportunity to live within a few hundred yards of the Caloosahatchee. Although Bruce was the architect, the pair shared the joy of designing their home together.

The house was first completed in 1978 in the distinct International style. The futuristic trend, first popularized in the 1930s, was revived by a group of architects known as the New York Five. The sharp lines, vertical and horizontal contrast, high ceilings, and open floor

plan define this residence. Finished in stucco with minimal exterior ornamentation, the two-story, flat-roofed house sits tucked behind a mature landscape.

Common for the time and style, a two-car garage sits foremost on the facade. The vertical design and asymmetrical layout of the structure, overall mass, and landscape minimize the often-obtrusive appearance of most front-loaded garages.

A recessed entry welcomes guests into the public area of the home. This leads to the linear hallway, which assists in defining the form while serving as the access to the guest rooms and family room. Rich with light and volume, the entry gives glimpses into the interior. The abundant use of glass offers views onto the pool and surrounding courtyard.

The three-bedroom, two-bath home boasts the most modern finishes and fixtures for the late 1970s Contemporary International style. Few changes have been made throughout the decades. Exceptions include the recently renovated guest powder room and the hardwood flooring laid throughout the main living areas.

A recessed living room anchors one side of the entry corridor, while the kitchen, dining room, utility area, and garage flank the other. A modest staircase leads to the master suite and to the loft office, which was designed for both Bruce's drafting table and Carolyn's art projects. Still used frequently by Carolyn, the space provides a view of the main living areas through to the outdoors. To maximize the use of the flat roof design, access to an outdoor space was incorporated above the garage with a direct site line to the Caloosahatchee. A rear second-floor deck provides a more private area overlooking the pool and courtyard, while the canopy of trees creates added seclusion.

Finished with the home and settling further into Fort Myers life, Bruce and Carolyn did not idly sit back and relax. They welcomed their first child in 1980. The following year Bruce, along with Dan McGahey, opened what would become a prominent and award-winning design firm, Gora McGahey Associates in Architecture. The mid-1980s brought the arrival of couple's second child, as well as an addition to the home. The expansion included another bedroom and a family room designed around the pool and courtyard. The addition increased the privacy of the outdoor spaces.

Though they built a unique home in the Caloosa neighborhood, Bruce and Carolyn never experienced resistance from the neighbors. Instead, the Goras stayed because of the people and the varying architectural styled neighborhood. As the years passed, plans to build again never

A view of the living room from the open-air second story. Photograph courtesy of Andrew West.

came to fruition. They created their lives, careers, and family in this forever home.

Today, the children are grown and have their own lives beyond Florida's borders. Bruce has since passed away, and Carolyn retired from teaching, yet life is anything but quiet. The two had been longtime community supporters and advocates for art, music, and cultural programs, and Carolyn continues the Gora legacy through her service on various boards, organizations, and initiatives in Fort Myers.

When asked if she has any future plans to downsize, Carolyn is quick in her simple reply, "No. I love this house. How many people get to live in a house their husband designed, they raised their children in, and still love?"

RIGHT: The office inspires the Goras' creativity. Photograph courtesy of Andrew West.

OPPOSITE: The pool is the central feature of the L-shaped home. Photograph courtesy of Andrew West.

25

Inspiring International

3402 West Riverside Drive

ALTHOUGH INTERNATIONAL BUILDINGS are typical throughout America, they are rare in Fort Myers. The style was created in the early twentieth century by European architects, many of whom found refuge in the United States during World War II. With advancing technology touching daily life, Swiss-French architect Le Corbusier referred to this design as a "machine for the living." The structural skeleton form is best suited to large buildings, thus most examples are designed by architects in high style.

This 1980s residence is a surprising sight along the Caloosahatchee riverfront. The house displays classic architect-designed characteristics. The prominent cylindrical form comprised of a glass block "window" is a key facade elaboration of the International & Postmodern style. Modern influence is also expressed in the variety of shapes fashioning the exterior plan, such as the gable and hipped roof sections and the side garage. The large expanse of smooth stucco-finished walls, as well as the asymmetrical entry door framed by the contemporary columns that are so common in Florida, create a more localized sensibility.

26

Cracker Box

2506 McGregor Boulevard

FLORIDA PIONEER HOMES had designs guided by function and livability in the hot, humid state. The "Cracker" name derives from the cracking sound of the whips used by pioneer cattlemen. This style is commonly known today as "Old Florida."

Cracker houses are characterized by shallow pitching rooflines, broad overhangs, sweeping porches, and pier bases. Its elevation protected the home during the frequent heavy rains, and allowed for air circulation, cooling it in summer. Expansive porches protected outdoor living space, the overhang creating additional shade. And some of the oppressive heat inside flowed out through attic space.

The presence of traditional Cracker houses lessened in the evolving urban areas during the early twentieth century. However, many of the functional features were incorporated into the Mediterranean and Spanish styles. The practical elements of these early homes disappeared with the advancements in building technology of the 1950s. Massive flood control projects, the addition of fill to raise land height, and central air conditioning added to the demise of the folk house.

Perhaps a sense of nostalgia or a desire to be less obtrusive in the natural landscape

Built in 2000, the design of this home is inspired by the vernacular Florida Cracker house style. Photograph courtesy of Andrew West.

has caused the gradual adoption of Old Florida vernacular design in new construction. Importantly, more stringent building code requirements and insurance regulations prove that the elements of this design make sense in the modern era.

This home singularly defines the contemporary use of traditional Florida vernacular. Barely visible from the McGregor Boulevard entrance, the home is located along the Caloosahatchee River, nestled among stately oaks dripping with Spanish moss, creating a more rural scene.

Varying roof planes and simple structural form add interest while minimizing the appearance of the over-all size of the house. The central section is highlighted by an enlarged rectangular cupola ascending above the low-pitched hipped roof. A band of multipaned square windows transitions to the twin shed dormer side wings encompassing the main section. This design is repeated in the front porch below.

The porch is finished with modest Victorian-influenced detailing consisting of traditional square columns, railings, and decorative trusses. The front-gabled roof is repeated in the dormer window. Other elements, such as a shed dormer above a modest projection, draw attention to the facade.

Completing the facade is what at first appears to be a three-stall side-entry garage but is equivalent in size to a four-car garage. Designed with both the gabled roofline and door placement, the garage cleverly blends in with the home while creating a space large enough for the owner to pursue a long-desired hobby: constructing his own RV-12 airplane.

Finished in 2001, the home is very different from the one that Bruce and Pam Stanley first bought in 1986. Early in their marriage the Stanleys relocated from Coral Gables, Florida, to Fort Myers. Bruce, an attorney, had an opportunity to further his career. He was familiar with the area, having spent many winters as a child with his family on Fort Myers Beach. Witnessing development in other parts of the state, he foresaw the growth of Fort Myers.

After moving to Fort Myers, Bruce and Pam, with their first child, occupied a rental home. Learning that they were expecting twins prompted them to search for a home of their own. As luck would have it, Bruce knew from first seeing the "For Sale" sign on this property that it was the perfect spot for his family.

Pam, on the other hand, took some convincing. She recalls touring the property that first time on a rainy

afternoon and telling Bruce, "Absolutely not." Soon to be a mother of three, the original 1950s concrete block home in a state of extreme deterioration was not appealing. In fact, the pair laugh at the "agreement" they negotiated to convince Pam that the home would suffice. Bruce, certain it would be unlikely to find a waterfront lot of this size at an affordable price, used his professional skills. Pam agreed after being assured that certain work would be done before move-in day. Immediate plans for major renovation and a future expansion sealed the deal.

Mature oaks defined the placement of the new house. Photograph courtesy of Andrew West.

Those early few years passed, and plans for renovation were under way until the neighboring 1950s ranch home sold. It was soon demolished and several feet of fill was placed prior to beginning construction on what was evidently to be a large new home. The Stanleys realized that their future plans of a modest renovation would not be money well spent. As the neighboring home took shape, the Stanleys' thoughts turned toward the idea of razing their own home. The new house, however, had to be built to suit both the family and the existing lot.

Through various inquiries and meetings, the couple put together what they glowingly refer to as the "A Team." Local architect Kathryn Kelly and longtime builder Howard Wheeler Sr. could give them the results they wanted. Kathleen is highly skilled at Florida vernacular and an advocate of preserving natural features, while the Wheeler

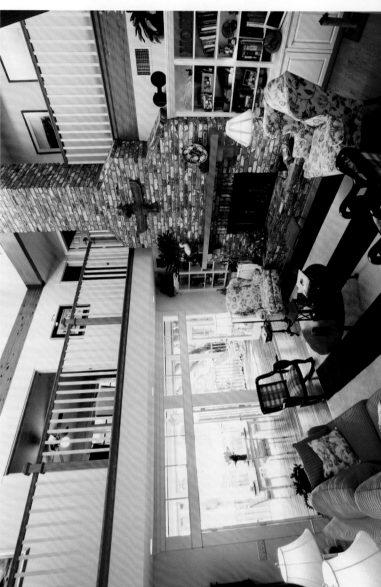

LEFT: *The great room opens to the third-story cupola. Photograph courtesy of Andrew West*

OPPOSITE: *Indoor-outdoor living is an important part of the owners' lifestyle. Photograph courtesy of Andrew West.*

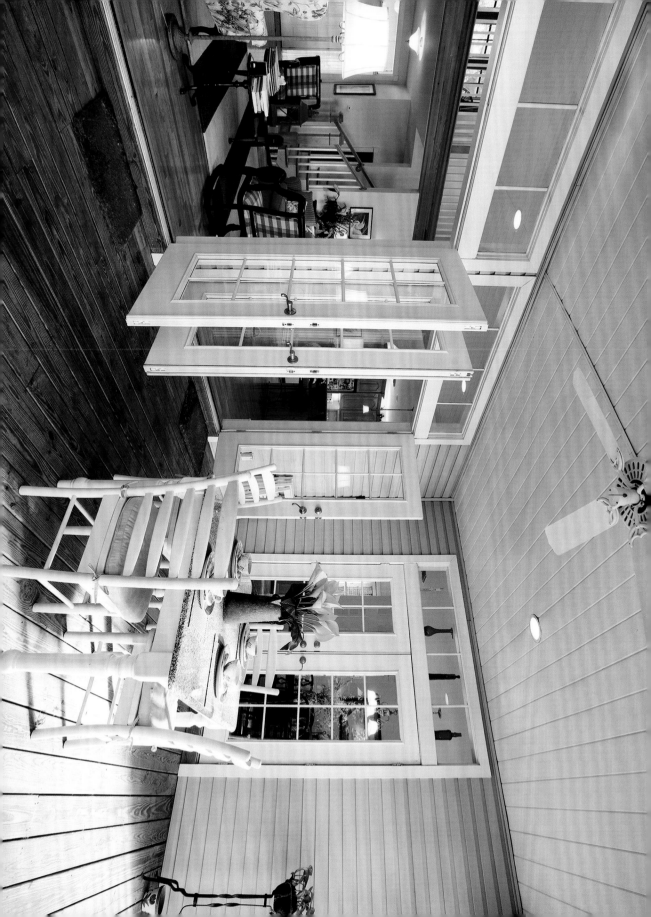

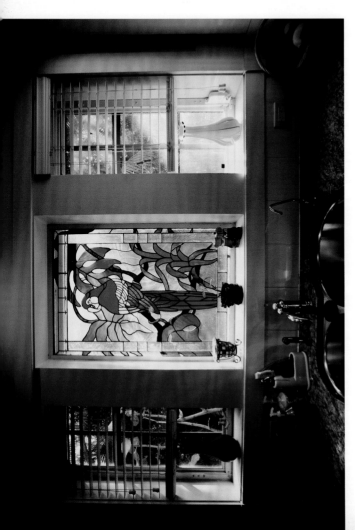

LEFT: *Pam made this stained glass window above the kitchen sink.* *Photograph courtesy of Andrew West.*

well as light shining down from the rooftop cupola, filling the space with comfort and warmth. Although the children have grown and left, grandchildren now run along the second-floor balcony overlooking the central living room on the first floor. The adjacent kitchen and dining room blend effortlessly. All three spaces lead to the enclosed rear porch, which is often used as an extension of interior space.

Completing the ground floor are the master bedroom, an office for Pam, and utility spaces that meet most of the Stanleys' current needs. Bruce still finds solitude in his upstairs office offering sweeping views of the river. The second-floor bedrooms and family room are perfect places for visitors.

Bruce and Pam described the construction process as one of great enjoyment. The home, finished with meticulous detail and craftsmanship, expresses the combination of the Stanleys' vision and Kathryn's and Howard's skill and sensitivity. This house epitomizes the partnership and passion that have created a much-loved home.

OPPOSITE: *A porch view extends from the lawn to the river.* *Photograph courtesy of Andrew West.*

family business, now known as Chris-Tel Construction, had built many examples of what today we think of as "Old Fort Myers." The company has more recently become a leader in the restoration of historic buildings, including those of the Edison & Ford Winter Estates. The Wheelers brought a level of craftsmanship to this project not found in mass-produced houses.

The home is flooded with light from a wall of French doors opening onto a stunning Caloosahatchee view, as

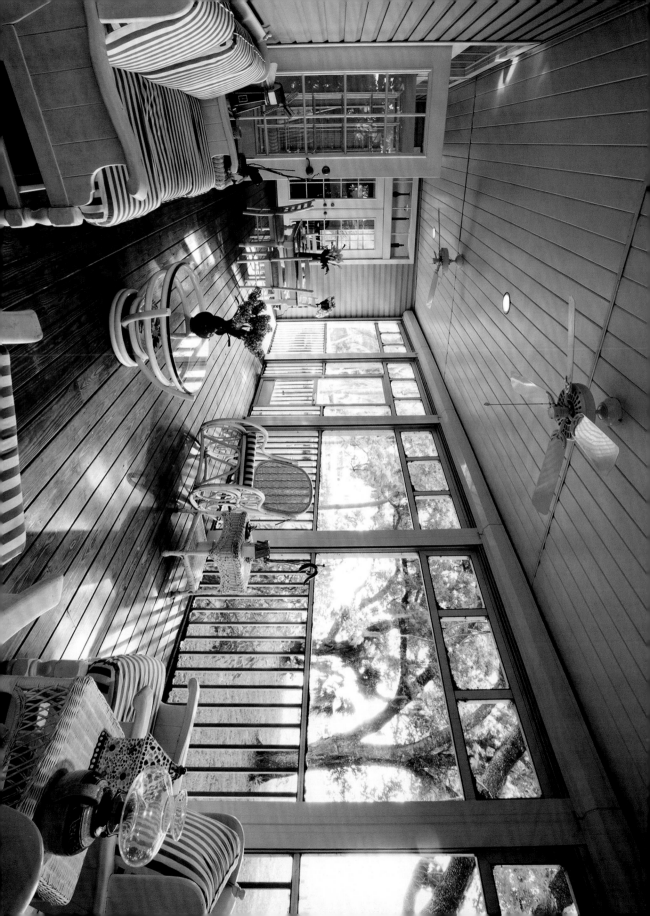

French Souvenir

1222 Miracle Lane

MIRACLE LANE, extending west from McGregor Boulevard to the Caloosahatchee River, is an interesting example of one of the few dead-end streets within the city limits. This is a one-street subdivision platted as Beckler's Riverside Addition in 1955. Noticeably, only arching coconut palms soar along the north side. The south side is lined with homes dating from the 1950s and 1960s. Miracle Lane conjures up a midcentury Florida postcard view boasting the modern housing and tropical foliage that the Sunshine State had to offer.

Standing prominently at the end of Miracle Lane is a house that changes this nostalgic view. Surrounded by a decorative wall and fencing, the home brings a taste of French elegance to the neighborhood. Patrick and Lisa Bridgette created this dream home.

A career opportunity brought the couple to Fort Myers from Columbus, Ohio. Lisa, previously with the Abercrombie & Fitch retailer, accepted a new role as lead designer for the Fort Myers–based White House Black Market women's clothing company.

Sharing similar tastes, the Bridgettes knew exactly what they wanted in a home. However, they did not expect to find it in Fort Myers. Seeking a home that would meet

OPPOSITE: Travels throughout France inspired the owners' vision for their new home. Photograph courtesy of Andrew West.

their needs, be convenient to Lisa's work, and be comfortable to spend family time in, the pair initially settled for a newer home in a gated community.

Although their initial choice checked off many boxes, the two began thinking about an ideal home. After looking at existing houses, they decided the best option was to build exactly what they wanted. An available vacant lot on Miracle Lane (the previous house had been demolished thirty years earlier) was the perfect size and location.

Bringing a bit of worldly touch to this quiet street

Detailed wall paneling is understated with a monotone paint. Photograph courtesy of Andrew West.

was natural for the Bridgette family. Patrick hails from Ireland, and the couple's life has included frequent travel to the Emerald Isles and beyond. Both are interested in architecture and share a love for Parisian-influenced homes, notably those of the Haussmann era. During the mid-1800s, French Emperor Napoleon Bonaparte III

enlisted Baron Georges-Eugène Haussmann to reenvision the transformation of Paris from an aged city to the modern capital of France. Much of his plan exists today, whether original to his time or later built to be representative of the style.

Armed with countless pictures taken during their

Custom flooring and finishes spread throughout the interior. Photograph courtesy of Andrew West.

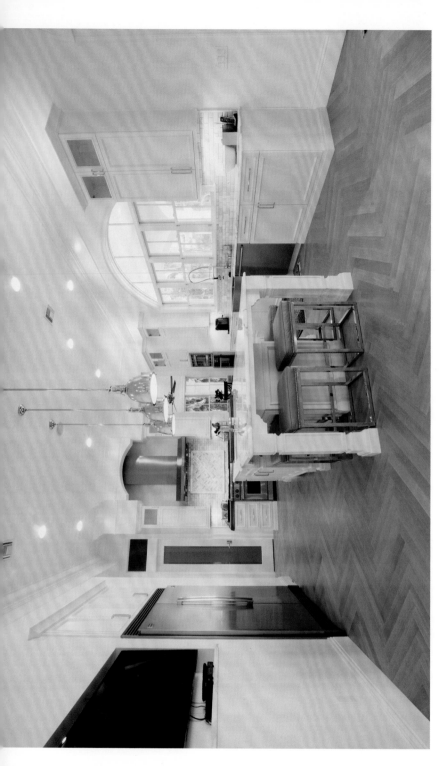

The popular French Country–influenced kitchen flows directly into the living space. Photograph courtesy of Andrew West.

travels depicting the French influences they desired, Patrick and Lisa began interviewing architects and builders to create their visions. They found what they were looking for in local architect and builder Joe McKenzie, who focuses his business on high-end custom homes.

The highly styled residence has a relatively simple floor plan. Mostly rectangular in form, the centered front protrusion serving as the formal entry and a three-car side garage complete the footprint.

The smooth stucco finish sets the tone for the classic detailing used throughout the exterior. Characteristics identifying the owners' interpretation of the

Haussmann influence include flanking chimneys, French doors with half-round transoms, vertical rectangular windows, substantial trim, an iron railing on the second-floor balcony, and a front terrace. These components hint at the interior experience.

Oversize mahogany and beveled glass double-front entry doors, handcrafted in Honduras, open into a light and airy reception hall. The direct view to the Caloosahatchee provides a stunning welcome. A custom Art Deco–influenced iron railing accentuates the open staircase leading to the second floor. The formal dining room and study flank the central hall, which transitions into the open kitchen and living area.

A monochromatic color palette is used throughout the interior. Layers are created with custom wood elements. Art Deco–influenced raised panel molding embellishes the walls, linked by trim and crown moldings. The custom rift and quarter-sawn herringbone patterned oak flooring extends throughout and reflects the light flowing in from numerous windows. The twelve-foot ceilings emphasize the tangible volume.

The French Country–inspired concept continues in the kitchen with an informal dining nook. The living area is anchored by the large fireplace, flanked by doorways to

the informal living room on one side and the media room on the other.

The French doors extending along the river side access the outdoor loggia and the terrace living and dining spaces. The pool, spa, and rear lawn stretch to the river.

The second floor includes four bedrooms and four baths. With ten-foot-high ceilings, the space is finished and furnished with as meticulous an attention to detail as the first floor. Most impressive is the master suite containing walk-in handcrafted closets, a bathroom, a

A well-executed molding detail in a door panel. Photograph courtesy of Andrew West.

dressing room, and a sitting area. Direct access to the rear second-floor terrace completes this personal oasis.

This new home was clearly designed and built with the detail and quality craftsmanship seen in so many of the stately older homes along the McGregor corridor.

Undoubtedly it is a house that many decades from now will be considered a part of Old McGregor. Patrick and Lisa, as well as Joe, found genuine enjoyment in the project. The results are clear in the beautiful residence on Miracle Lane.

RIGHT: *A magnificent view of the Caloosahatchee. Photograph courtesy of Andrew West.*

OPPOSITE: *A tranquil scene is created by the house's reflection in the pool. Photograph courtesy of Andrew West.*

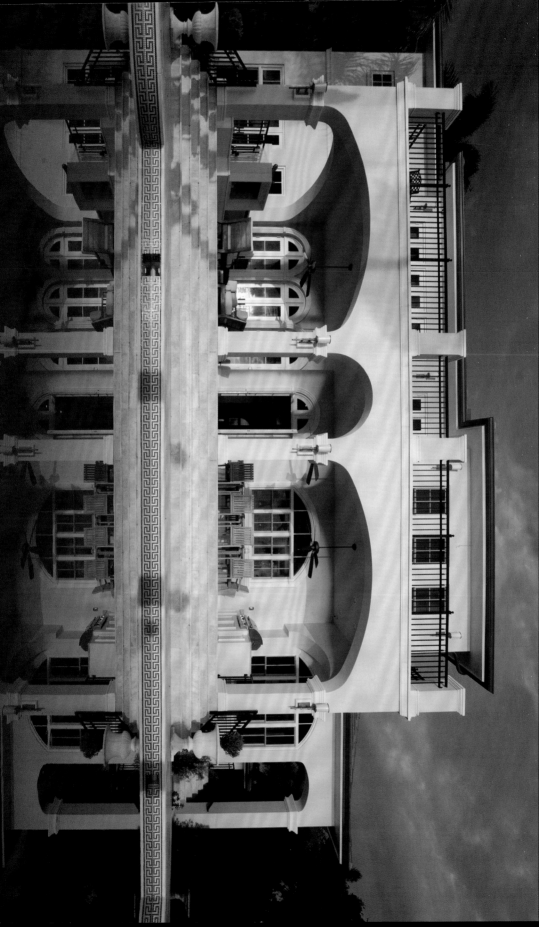

28

Twenty-First-Century Modern

1324 Florida Avenue

OAHU AND MAUI were two of three relocation contenders for newlyweds Mike and Jenny Lewis when they left their native Saint Louis, Missouri. Close family bonds proved to be the deciding factor in selecting Fort Myers. The couple quickly realized that the community was large enough for Mike to build his ophthalmologist career. And the proximity to open water suited the two avid sailors.

The Lewises first settled into a rental house in Fort Myers in 2004. Hurricane Charley roared through the area soon after their arrival. Mike and Jenny realized that the rapid onset of the escalating real estate market, further compounded by the destruction caused by the massive hurricane, had complicated their selection of a home.

Like the advertisements of the notorious 1920s housing boom, the couple experienced firsthand the exaggerations of the local realtors when they chose a waterfront Cape Coral lot that was "just minutes" from open boating in the Gulf of Mexico. In actuality, they found the Gulf shores to be forty-five

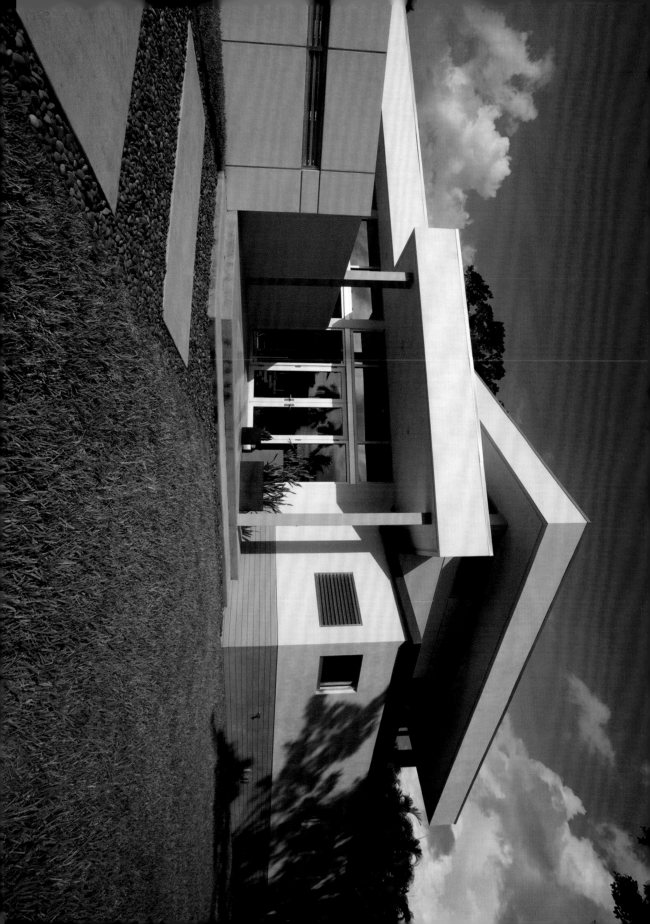

minutes away from the lot by boat. The search for their elusive ideal residence stretched out over several years.

Mike and Jenny had already purchased and owned two houses and a canal front lot since arriving, none of which they wanted to keep. Even though the real estate market began to go bust, the Lewises were confident they would sell the properties in due time. As their newest search began, they were drawn to the old McGregor area because of the riverfront access, mature tree canopy coverage, and diverse architecture.

Two wish list items continued to be a challenge to find in the historic neighborhood: water access and modern architecture. Mike, a Modern-style admirer, once considered pursuing a career in architecture. Jenny is equally a fan of the contemporary. They eventually resolved to design and build a dream home. Armed with drafting and 3-D visualization software, Mike began putting ideas to paper.

During this process, the couple discovered a Mid-Century Modern house on a double-wide lot for sale on Florida Avenue. The lawn's large Cuban laurel and other mature trees further captured their attention. Though the home was in a severe state of deterioration and proved beyond restoring, the lot size fit their vision.

Enthusiastic, the couple began interviewing architects to refine and implement the design. In the interview process, having toured countless houses, they realized that finding a team skilled in the Modern style could be a challenge. They selected Jeff Mudgett, a second-generation member of Parker/Mudgett/Smith Architects, in Fort Myers.

Mike and Jenny already knew Jeff. He and his family live two doors down the street. Having a vested interested in the neighborhood would be an added benefit. Jeff's experience with residential and religious projects, where light and volume within spaces play a significant role, and his practical approach sold the couple.

Working with Jeff, the couple interviewed general contractors and found Kingsley-Parker. The company was hired because of its commercial and institutional experience with Modern-style buildings. It was currently in the final stages of renovating a home in the same Florida Avenue neighborhood. Company partner Wiley Parker Jr. is the son of Wiley Parker, founding member of Parker/Mudgett/Smith.

With the team in place, the formal design was completed and construction began. Mike and Jenny selected every finish, fixture, and feature to ensure that the

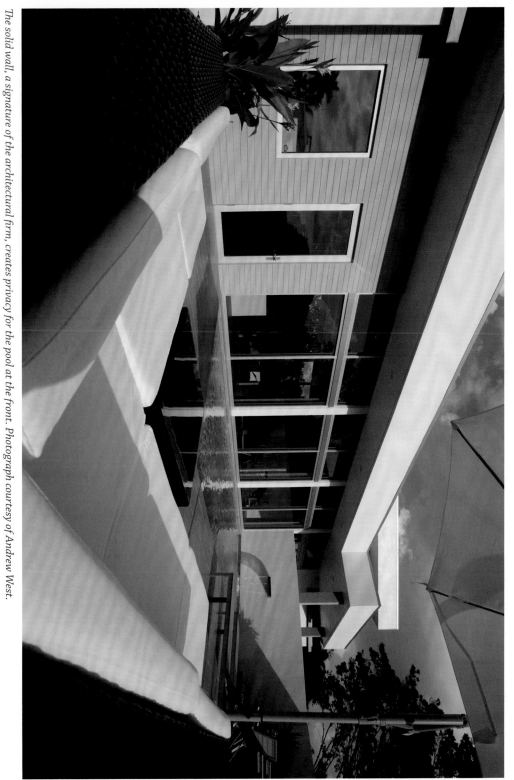

The solid wall, a signature of the architectural firm, creates privacy for the pool at the front. Photograph courtesy of Andrew West.

outcome would be exactly what they envisioned. Contrary to common assumptions, the smooth, crisp lines and minimal detailing of modern design added complexity to the project. Without conventional trim and detailing, there is little room for error or imperfection.

The Lewises share that from their perspective it was a challenge at times for the various subcontractors to grasp Modern styling in a region that tends to lean toward ornamented design. They, as well as Jeff, played a hands-on role throughout the process. The result is a one-of-a-kind dream home.

The floor plan was altered to fit around the existing Cuban laurel tree and open to the large rear yard. The elegantly unified modern design is identified by strong horizontal lines, window size and placement, oversize fascia, a stucco finish, and simple light paint colors.

A privacy wall extending from the large glass-and-aluminum-framed double entry doors and surround is a common feature used by Jeff on residential projects.

The Industrial-style entry opens into a massive expanse of calming light space. Centering the first floor is the open staircase made of recycled wood. The open family living room, clearly a design masterpiece, anchors one side and is flanked by two walls of solid glass. One wall visually extends to the pool area, which is hidden from the street by an exterior privacy wall. The other interior wall frames a Japanese rock garden in the rear that has been designed to be converted to a koi pond.

Both spans of solid glass windows in the family room give the appearance that the house is atop the pool and rock garden. This spot, which offers a broad view of the rear yard through floor-to-ceiling windows is Mike and Jenny's favorite space—Jeff's too. Once the rock garden is converted, it will look as if the pool and pond meet below. The colorful foliage and the blue hues of the pool contrast with the muted colors of the space.

The opposite side of the first floor is anchored by a series of rooms. Jeff encouraged the couple to include this area to balance the volume of the open living room. This section includes a cozy family room, a sound-proofed media room, their two daughters' bedrooms, a guest bedroom with bath, and a utility room.

The level of consideration that went into the home is experienced when entering the corridor to this wing. Unexpectedly, at the end of the hall is an oversized window framing a bamboo tree, additional foliage, and

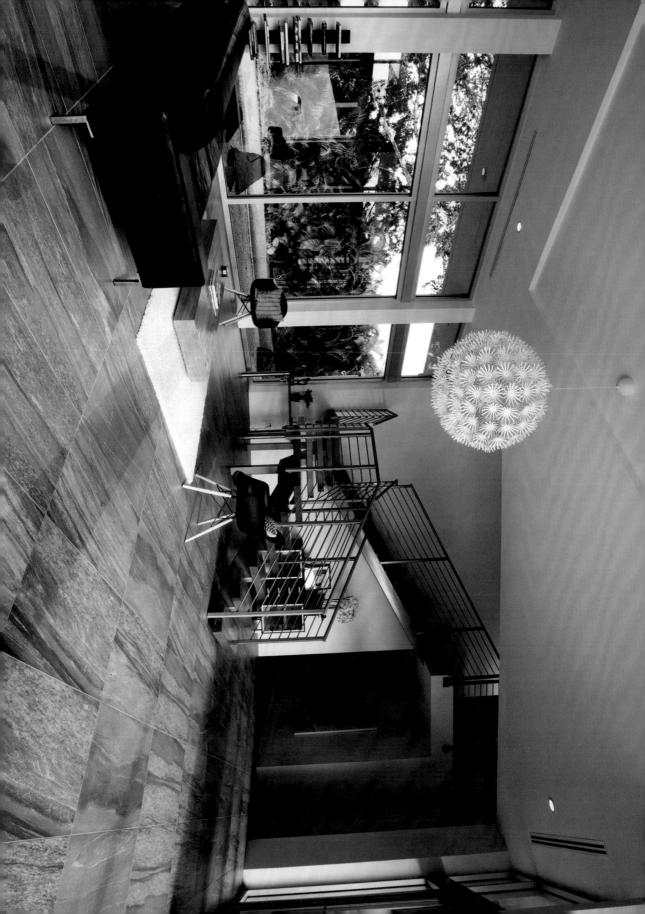

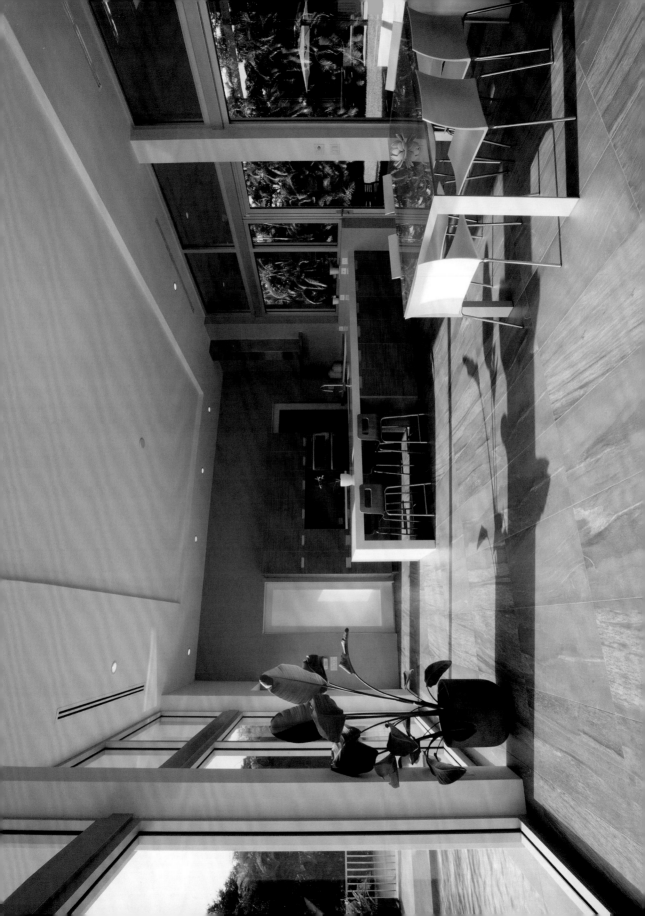

a small bench. Collectively the relaxing space that would typically have been left as a "dead" space looks like art and is one of many spirited debates with Jeff that Mike is glad to have won.

The second floor includes a master suite retreat for Mike and Jenny. The bedroom's stunning solid row of windows, designed to be high enough to provide privacy, double as a frame to the exterior and flood the space with sunlight and colorful foliage.

Interior details such as the twelve-foot-high ceilings and crisp lines flowing from room to room further illustrate the modern intent. Contemporary furnishings throughout complete the vision.

Although the home was not designed with an eye toward LEED (Leadership in Environmental and Energy Design) certification, practical principles were used in its construction that are often not considered. The orientation of the house on the lot factored in sun angles. Broad overhangs were enlarged to block direct sunlight while still allowing ample overflow light inside. Renewable bamboo and stone flooring, and minimal detailing

with natural finishes accent the design, fixtures, and furnishings.

The Lewises endeavor is missing one key thing: waterfront. However, Mike and Jenny's journey ends with a home they love, in a neighborhood that suits them perfectly, in a city where they plan to stay. The exemplary contemporary residence by a local architect secures the future of historic Fort Myers.

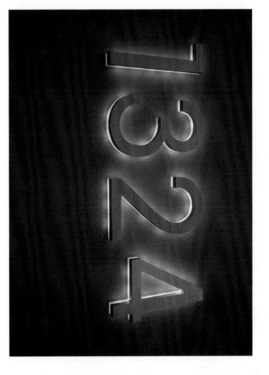

OPPOSITE: The open floor plan flows through to the dining room and kitchen. Photograph courtesy of Andrew West.

LEFT: Modern style exists in every detail, even the house numbers. Photograph courtesy of Andrew West.

Acknowledgments

CONVERSATION DURING LUNCH in downtown Fort Myers sparked an idea for a book. As professionals in the disciplines, we know the significance of the history and the architecture existing in Fort Myers. We want to provide a source for others to learn this as well.

After several months of afternoon drives, research, and an accepted proposal to publish, this journey truly began. The result shares our perceptions of Fort Myers, a city rich in tradition, architecture, and people who infuse vibrant life into historic neighborhoods.

While remembering all those who have invested in this area of Fort Myers, we are grateful to the homeowners, who welcomed us into their homes and shared their experiences.

Thank you to Patrick and Lisa Bridgette, John Carbona, Mina Corbin and Ginny Henderson, Brent and Florence Crawford, Clay and Jeana Crevasse, Bernese Davis, Gary and Heather DeMarinis, Marjorie Whitehurst Berry Gilbert, Carolyn Gora, Mitch and Susan Hodge, Dr. John and Francis Fenning, Michael and Jennifer Lewis, Sean McGowan and Eric Smith, Darilyn Alderman, Corey and Susy Mertz, Dr. Alejandro and Barbara Miranda-Sousa, Joyce Owens, Dr. Omar Rieche and partner Len, T. J. and Amy Singer, James and Debra Ferrari-Stone, Marnie and Tony Paulus, Judge James and Diann Seals, Bruce and Pam Stanley, and Marc and Carol Yorkson.

We thank photographer Andrew West, whose talent brings words to life through amazing images of these beautiful homes. His kindness and professionalism are admirable.

We thank Pam Kennedy for her talent and objective view when editing our words expressing the stories these houses tell. We appreciate the positive reviews and helpful suggestions by Gerri Reaves and Linda Stevenson.

Additional information, images, and access to homes were generously provided by photographer Josh Fisher; the Southwest Florida Historical Society; the Southwest Florida Museum of History; the Office of the Lee County Property Appraiser and Lee County Clerk staff member Joanne Iwinski-Miller, Fort Myers City Clerk Marie Adams; architects Joe McKenzie, Jeff Mudgett, Toni Ferrell, Joyce Owens, and Robert Sanford; and realtor Millie Dinkle. Thank you.

Thank you to our families, friends, and colleagues. Thank you to the Fort Myers history, design, and preservation communities. All continually expressed interest and provided support throughout this endeavor.

We thank the University Press of Florida for partnering with us to share our vision. Director Meredith Morris-Babb, assistant editor-in-chief Sian Hunter, editorial assistants Shannon McCarthy and Stephanye Hunter, as well as the acquisitions, editorial, design, sales, and marketing teams, made the process easy and fun.

The opportunity to present this coffee table book is an honor.

We thank you for selecting this book to learn about an important story the City of Palms has to tell. We hope you are encouraged to take a drive, give new life to an old home, or build a new one along a river or a road in Fort Myers, Florida.

Selected References

Board, Trudy Taylor. *Remembering Fort Myers: The City of Palms*. Charleston, SC: History Press, 2006.

"Demographic Profile." Fort Myers Regional Partnership. Fort Myers, FL: Lee County Economic Development Office, 2010.

Duchscherer, Paul, and Douglas Keister. *The Bungalow: America's Arts and Crafts Home*. New York: Penguin Studio, 1995.

Grismer, Karl H. *The Story of Fort Myers: The History of the Caloosahatchee and Southwest Florida*. Fort Myers Beach, FL: Island Press Publishers, 1982.

Hatton, Hap. *Tropical Splendor: An Architectural History of Florida*. Hap Hatton, 1987.

Jacobs, T. M. *H. E. Heitman: An Early Entrepreneur of Fort Myers, Florida*. T. M. Jacobs, 2009.

Katz, Peter. *The New Urbanism: Toward an Architecture of Community*. New York: McGraw-Hill, 1994.

Keuler, Angela. "Thilmany Pulp and Paper Company: Surviving History's Economic Hardships." History 489 Seminar, Department of History, University of Wisconsin–Eau Claire, Spring 2008.

Lee County Alliance of the Arts. "The Designer Showcase House 1986." Booklet. Courtesy of Carol Yorkson.

Maltz, Allan. *Visions of Beauty: Fort Myers, Sanibel, and Beyond.* Key West, FL: Light Flight Publications, 2010.

McAlester, Virginia, and Lee McAlester. *A Field Guide to American Houses.* New York: Alfred A. Knopf, 2011.

Mormino, Gary R. *Land of Sunshine, State of Dreams: A Social History of Modern Florida.* Gainesville: University Press of Florida, 2005.

Morrison, Buck. "George W. Whitehurst: Panoramic Jurist Extraordinaire (1891–1974)." Florida Studies Center Publication. 1998 Digital Collection. Paper 2501. Last accessed 2015. http://scholarcommons.usf.edu/flstud_pub/2501.

National Register of Historic Places. Jewett-Thompson House, Fort Myers, Lee County, Florida. National Register #88001708.

National Register of Historic Places. Casa Rio, Fort Myers, Lee County, Florida. National Register #96001186.

Nolan, David. *Fifty Feet in Paradise: The Booming of Florida.* San Diego: Harcourt, Brace, Jovanovich Publishers, 1984.

Pierson, William H., Jr. *American Buildings and Their Architects.* Vol. 1, *The Colonial and Neoclassical Styles.* New York: Oxford University Press, 1970.

Rifkind, Carole. *A Field Guide to Contemporary American Architecture.* New York: Penguin Group–Dutton, 1998.

Swan, Herbert S. *The Fort Myers Plan.* Fort Myers, FL: Planning Board of Fort Myers, 1926.

Stronge, William B. *The Sunshine Economy: An Economic History of Florida since the Civil War.* Gainesville: University Press of Florida, 2008.

Taylor, Robert A. *Rebel Storehouse: Florida in the Confederate Economy.* Tuscaloosa: University of Alabama Press, 1995.

White, Randy Wayne, and Carlene Fredericka Brennen, eds. *Randy Wayne White's Ultimate Tarpon Book: The Birth of Big Game Fishing.* Gainesville: University Press of Florida, 2010.

About the Authors

JARED BECK, AICP, is an urban designer and community planner. Stemming from a bachelor of landscape architecture degree, the breadth of his professional skills ranges from large-scale planning to detailed architecture and design. With more than fifteen years in both private and public roles, his focus is now on reinvestment programs and projects that recognize and work within the unique built environment that exists in our communities.

Inspired by the developing energy to revitalize historic downtown Fort Myers, Mr. Beck relocated from his prior home in Naples, Florida, a decade ago to become a part of the transformation. Since then, he has been involved in a variety of projects and programs focused on community revitalization, while also serving on numerous local and state committees and boards encouraging quality community design and reinvestment initiatives.

Today, he balances his professional role in the private sector doing consulting work focusing on physical reinvestment projects while also working within the nonprofit field to further economic development efforts within historic downtown Fort Myers and other similar communities.

Although a Michigan native, Mr. Beck is still as enamored with the Sunshine State as when he first began his career. As an Old Fort Myers resident, he has found this project both rewarding and personal.

PAMELA MINER is a historian, educator, and museum professional. With a master's degree in history/historic preservation, she has been active in the field for more than thirty years. During Pamela's eighteen years in Missouri, her work included countywide reconnaissance surveys with the Missouri Historic Preservation Office.

Pamela's interest in local history began as an undergraduate student. She has continued to study this subject area throughout her career. As an archivist for the Missouri Local Records Program, she expanded her expertise on the "common" man (and woman).

As a youth, Pamela spent family vacations on Southwest Florida's gorgeous beaches. She has called this area home for over seventeen years. Pamela enjoys researching and presenting information about people, places, and events that bring this tropical paradise to life.

Pamela served as board member, vice president, and president of Missouri Preservation.

In Southwest Florida, Pamela has served as board member and president of the Lee Trust for Historic Preservation. She was a key member of the restoration team at the Edison and Ford Winter Estates, where she was curator of collections and interpretation. Pamela was also adjunct professor of history at Florida Southwestern State College and has held various positions within the Collier County Museum system.

Index

Page numbers in *italics* indicate illustrations.